DRAWINGS BY MICHELANGELO

FROM

THE BRITISH MUSEUM

The Pierpont Morgan Library

NEW YORK

CONTENTS

FOREWORD

THE Pierpont Morgan Library is pleased to publish this volume containing forty-one drawings by Michelangelo, on twenty-four sheets, from one of the two most important collections of his drawings, that in the British Museum. We are most grateful to the Trustees of the British Museum for making this book possible and permitting these drawings to be shown in New York. This publication commemorates the first occasion when more than a handful of works by Michelangelo will be on exhibition outside of Europe. The photographs have all been made especially for this book and we have attempted to achieve a fidelity to the originals beyond that of previous publications. We have asked Mr. John Gere and his associates at the British Museum to re-consider the attribution of all of the drawings shown here, although, admittedly, it is not possible to add a great deal to our knowledge of these very famous sheets. Yet even the best-informed scholar will find some new and fascinating material in this work.

The drawings span Michelangelo's life (1475–1564) and illustrate practically all periods and phases of his career. With a few other related works by him from The Detroit Institute of Arts, The Metropolitan Museum of Art, and the Morgan Library, and about forty drawings from our collection by other Renaissance artists in Italy, they will be shown at The Pierpont Morgan Library from 24 April to 28 July 1979. In order to illustrate more fully Michelangelo's world, the Morgan Library will in addition display letters, manuscripts, and books of Michelangelo and his contemporaries concerning the painting, sculpture, architecture, literature, music, religion, and political problems of their time.

We are deeply indebted to Mr. Gere and his staff at the British Museum for writing this volume; to Dr. David M. Wilson, the Director, and Mr. Reginald Williams for their keen interest and repeated helpfulness. The photographs were made by Mr. Derrick Witty; he, Mr. John Peckham, and Mr. Roderick Stinehour assisted us greatly in preparing the illustrations or in the design of this book. Mr. David W. Wright, Mrs. Patricia Reyes, Miss Priscilla C. Barker, and Mr. Alexander Jensen Yow of the Morgan Library have also given special help. The exhibition in New York has been financed

chiefly through grants from Mrs. Charles W. Engelhard, one of our Trustees, and Philip Morris Incorporated. This catalogue and the exhibition have as well been made possible, in part, by grants from the National Endowment for the Arts, a federal agency. We are also grateful for support of the exhibition to the Museum Program of the National Endowment for the Arts through the Arts and Artifacts Indemnification Act.

<div align="right">
CHARLES RYSKAMP
Director
The Pierpont Morgan Library
</div>

PREFACE

THE drawings by Michelangelo reproduced in this volume have been chosen to illustrate, so far as is possible from the resources of a single collection, the successive phases of the artist's development. No. 1 is an example of his very early pen-and-ink technique of around 1500, which shows the youthful artist's instinct for sculptural monumentality already fully developed; no. 3 is certainly, and no. 2 possibly, connected with the *Bathers* cartoon of a few years later, which was to become the "academy" of the younger generation of Florentine Mannerists; nos. 4 to 7 are connected with the masterpiece of Michelangelo's early period, the Sistine Ceiling; 8 and 9 belong to the still controversial group connected with paintings executed by his Venetian protégé Sebastiano del Piombo; 10 and 11 are studies for the Medici Chapel; number 18 is an early sheet of sketches for the fresco of the *Last Judgment* on the altar-wall of the Sistine Chapel, which marks the beginning of the later phase of his development as a painter; 15, 16, and 21 are examples of the carefully finished drawings he sometimes made as works of art complete in themselves, to give to particularly favored friends; number 17—no doubt also a "presentation drawing"—is the likeness of one such friend, Andrea Quaratesi, and, incidentally, the only known surviving portrait-drawing by Michelangelo; finally, 23 and 24 represent the individual and inimitable style which he developed in Rome during his last years in the devout intellectual climate of the Counter Reformation, when he came to treat the human figure in a way verging on abstraction, to express a vision of transcendent spirituality.

Although Michelangelo sometimes made drawings to help his fellow artists or as gifts for his friends, he regarded (as every artist does) the mass of sketches and studies which he had accumulated in the course of his long career as the essentially private working material of his studio: so private, indeed, that, as Vasari relates, "shortly before his death he burnt a great number of sketches, studies, and cartoons, so that no one should ever know the extent to which he had struggled to achieve perfection." Fortunately the destruction was not total, for a large quantity of drawings and manuscript material, found in his house in Rome, was preserved by his collateral descendants

11

in the family palace in Florence until the beginning of the nineteenth century. Drawings genuinely by Michelangelo are thus relatively unusual in eighteenth-century collections. It is true that King George III bought some twenty for the Royal Library at Windsor, but there is no reason for supposing these to have come from the Buonarroti inheritance (such evidence as there is suggests that some if not all of them may have been acquired from the descendants of the Farnese family, who had owned them since the sixteenth century); but it is significant that there should not be a single one in the Devonshire Collection at Chatsworth, where the great masters of the High Renaissance are in general so superbly represented.

Soon after the French invasion of Italy in 1796, the Buonarroti Collection was divided between the surviving members of the family. One heir sold his portion to the French collector J. B. J. Wicar, who in 1823 disposed of his collection to the English dealer and expert Samuel Woodburn; another, in 1858, bequeathed his to the city of Florence, where it constitutes the present museum of the Casa Buonarroti; yet another share, consisting of thirty-six drawings, was bought directly in the following year by the British Museum, which until then had had only one drawing by Michelangelo, acquired as part of the Payne Knight Bequest in 1824. Today, the appearance of any one of these drawings on the market would create an international sensation; in 1859 it was with no display of undue enthusiasm that the then Keeper of Prints and Drawings, W. H. Carpenter, reported that he had "carefully examined the sketches recently received from Florence, some of which he finds to be of comparatively little interest, others not to be recognised as the work of the great master to whom they are attributed. There are, however, some few which do possess a certain degree of interest." His doubts were in fact justified in the case of only two: a composition-sketch correctly identified by an inscription on the verso as by a later Florentine master, Lodovico Cigoli (1559–1613), and a very Michelangelesque sheet of studies in black chalk, accepted by Berenson and other critics, but which Wilde convincingly reattributed to the Florentine sculptor Pierino da Vinci. Carpenter estimated the value of the total of thirty-eight drawings offered as about £100!

The purchase of thirty-six drawings by Michelangelo, remarkable coup though it was, does not in itself account for the fact that about two-fifths of the artist's surviving drawings are now in English collections. The credit for this must go to a private collector of an earlier generation, the great portrait painter and President of the Royal Academy Sir Thomas Lawrence (1769–1830), who had taken advantage of the political and social upheavals caused by the French Revolutionary Wars, and the consequent scattering of so many ancestral treasures, to amass the most magnificent collection of drawings by the Old Masters ever brought together by a single individual. This

included more than a hundred drawings by Michelangelo (many of which came, through Wicar and then Woodburn, from the Buonarroti family collection); and from it come all the fifty-odd in the Ashmolean Museum in Oxford, and of the total of eighty-five now in the British Museum no fewer than thirty-eight of the forty-nine not acquired directly from the Buonarroti family. Those in the Ashmolean Museum were presented to the University of Oxford by public subscription in 1845; those in the British Museum were acquired at intervals, by purchase or by gift, after the final dispersal of the Lawrence Collection at auction in 1860.

The connoisseurship of Michelangelo's drawings has passed through successive phases. The "scientific" hypercriticism of the later nineteenth century led students to detach from the master's oeuvre a number of important drawings traditionally attributed to him, giving some to his protégé Sebastiano del Piombo (see nos. 8 and 9) and dismissing others either as old copies or at best products of the shadowy and indeterminate inmates of Michelangelo's studio, "Andrea di Michelangelo," Antonio Mini, and the rest—because of their failure to fit into an *a priori* conception of the master's style. More recently, however, the catalogues of the Michelangelo drawings at Windsor (1949) and the British Museum (1953) by the late Johannes Wilde and of those in the Ashmolean Museum by Sir Karl Parker (1956) have argued in favor of the essential truth of the traditional view, and have produced a better-balanced and more convincing picture of Michelangelo's draughtsmanship.

Except for a few points of detail, the catalogue offers little in the way of fresh information. In a field that has been so intensively harvested by so many distinguished scholars, some of whom have devoted themselves solely to this apparently inexhaustible subject, there is indeed little or nothing to be gleaned. And any attempt to do so is not unattended by peril, for the terrain has taken on something of the character of a minefield, in which the non-specialist is well advised to tread delicately. We have, however, ventured to differ from Wilde in attaching more weight to Berenson's hesitations about the authenticity of one of the most conspicuous and celebrated drawings in the whole collection, the study for Adam on the Sistine Ceiling (no. 7); and, conversely, in reclaiming two slight sketches, one (no. 13 verso) explained by Wilde as the work of a pupil, the other (no. 22 verso) summarily dismissed as by "a very feeble hand." The entry dealing with nos. 8 and 9 is disproportionately longer than the others, but the publication of this volume seemed to provide a convenient opportunity for tracing in detail the history of the "Michelangelo-Sebastiano problem"—well defined by Kenneth Clark as "one of the heroic curiosities of connoisseurship." For that particular entry I am solely responsible; the rest of the catalogue was compiled jointly by myself and Mr. Nicholas Turner, Assistant Keeper in the Department. We have to

thank Mr. Philip Pouncey and Mr. Michael Hirst for advice on certain specific points. Mr. Hirst was also kind enough to lend me a copy of the chapter on the artist's drawings in his forthcoming monograph on Sebastiano del Piombo.

The Trustees of the British Museum and Dr. David M. Wilson, the Director, have asked me to express their great pleasure in this opportunity of collaboration with The Pierpont Morgan Library. They have sent to New York the largest concentration of drawings by Michelangelo ever seen in the Western Hemisphere; and these they hope will arouse as much pleasure and interest as the reciprocal loan exhibition of Dutch and Flemish drawings from The Pierpont Morgan Library will certainly do in London later in the year.

<div style="text-align: right;">

J. A. GERE
Keeper of Prints and Drawings
The British Museum

</div>

14

DRAWINGS BY
MICHELANGELO

1

A PHILOSOPHER HOLDING A SKULL (?) recto.

HEAD OF A YOUTH; A RIGHT HAND verso.

RECTO: pen and yellowish-brown and greyish-brown ink. VERSO: red chalk and black chalk over stylus, partly gone over in brown ink (the head) and black chalk (the hand). Four successive stages in the drawing of the head can be distinguished: (1) lightly sketched with the stylus; (2) outlined in red chalk; (3) elaborated in black chalk; (4) the profile emphasized in pen.

331: 215 mm. A hole repaired in the angle between the right forearm and drapery of the recto figure.

1895-9-15-498

PROVENANCE: J. D. Lempereur, B. Constantine, and T. Dimsdale (all according to Lawrence Gallery catalogue); Sir T. Lawrence (L. 2445); S. Woodburn (sale, Christie's, 1860, 4 June, lot 145, bt, *J. C. Robinson*, *£2-15-6*); Sir J. C. Robinson (signature and date *1860*, on verso); J. Malcolm of Poltalloch; purchased with the Malcolm Collection in 1895.

LITERATURE: Lawrence Gallery 3 (pl. 1, recto); JCR 61; BM Guide 1895, no. 128; Loeser 1897, p. 353; BB 1522; Steinmann, p. 598, note 2; Frey 41, 42; Thode 348; Brinckmann 26 (verso); Popp 1925/6, p. 142; E. Möller; *Belvedere*, ix (1926), pp. 39ff.; Baumgart 1937, p. 21; Tolnay 1943, pp. 67, 179 (no. 6: recto); Tolnay 1945, pp. 137, 202 (no. 43: verso); F. Hartt, *The Art Bulletin*, xxxii (1950), p. 242; Wilde 1; Dussler 171; Hartt 21, 245; BM exh. 1975, no. 1; Tolnay [i] 6.

THE earliest surviving drawings by Michelangelo, datable *c.* 1490, are copies in pen and ink in the Louvre, Albertina, and elsewhere, of figures in *Quattrocento* and earlier frescoes. Though the figure in the present drawing is apparently of Michelangelo's own design, it closely resembles this group in handling and in its sense of monumental form. Berenson and Wilde see it as more developed in style and therefore somewhat later, *c.* 1500-3. Tolnay, on the other hand, emphasizes its similarity to the copies and is inclined to date it at about the same time.

The subject and purpose of the drawing have not been satisfactorily explained. The figure has been variously identified as: a self-portrait; a prophet; a representation of Leonardo da Vinci as a teacher of anatomy; one of the Magi; an alchemist; a *modello* for a statue of St. James the Greater; and a philosopher. As Tolnay noted, there is a general resemblance to a drawing by Dürer, dating from his first visit to Venice in 1494, of an alchemist holding a skull—apparently also the object held by Michelangelo's figure. On the other hand, the hat resembles that worn by the Emperor John Palaeologus and is of a type used by *Quattrocento* artists to indicate Greek nationality, so that the figure may be intended as one of the Greek philosophers.

The pen-and-ink contour defining the head on the verso in profile is a *pentimento*: as first drawn, in chalk over stylus, the head was shown turned slightly to the left. The verso studies are clearly later than the recto drawing, though how much later is a

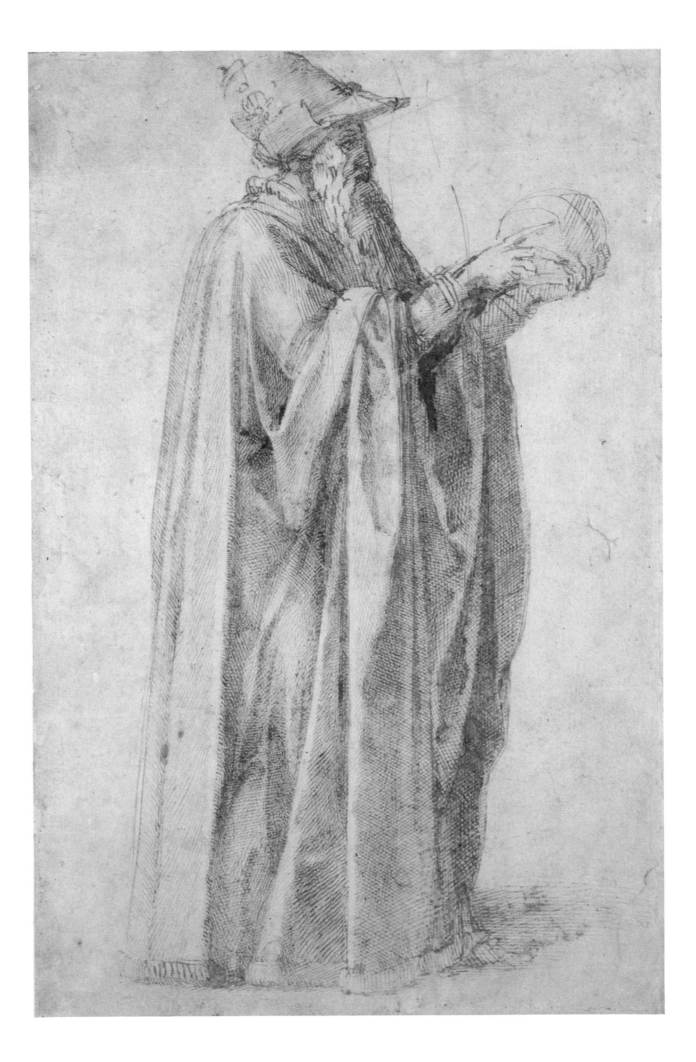

matter of argument. Tolnay sees the head as a study for Sebastiano del Piombo's *Lazarus* of *c.* 1517 (see no. 9); Hartt as a study for the figure of *Dawn* in the Medici Chapel, and thus datable in the early 1520s. We agree with Wilde and Dussler that the drawing must be earlier, in the period of the first half of the Sistine Ceiling (1508–10). Dussler follows Colvin in suggesting a connection with the head of Adam in the *Creation of Adam*, which is in the reverse direction (see no. 7). We find more convincing Wilde's observation that in each position of the head the drawing resembles one of the *ignudi*: the pen-and-ink profile, the one to the right above the *Erythraean Sibyl*; the head as first drawn, the one to the left above the *Delphic Sibyl*, in reverse (Tolnay 1945, figs. 116 and 111).

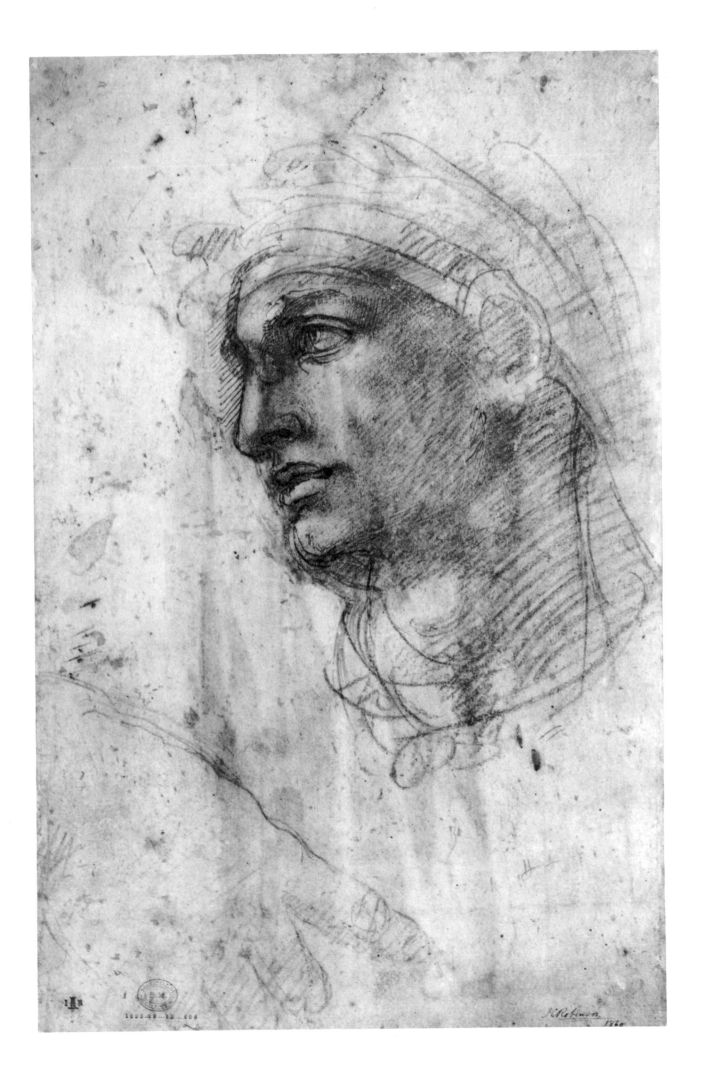

2
A GROUP OF THREE NUDE MEN; THE VIRGIN AND CHILD recto. A NUDE MAN SEEN FROM BEHIND; TWO STUDIES OF CHILDREN; A MAN'S LEFT LEG; FOUR LINES OF VERSE verso.

RECTO: black chalk (the group), pen and brown ink over lead-point (the Virgin and Child). VERSO: black chalk (the nude men), pen and brown ink over lead-point (the children), pen and light brown ink (the leg and the writing).

315: 278 mm. The sheet may originally have been taller: the horizontal crease about 10 cm. from the top possibly indicates where it was once folded in two.

1859–6–25–564

PROVENANCE: Casa Buonarroti (Michelangelo's great-nephew is recorded as having purchased this sheet from the collection of the Florentine architect Bernardo Buontalenti [1536–1608]: cf. C. Guasti, *Le Rime di Michelangelo*, Florence, 1863, p. lxii).

LITERATURE: A. Woltmann, *Zeitschrift für bildende Kunst*, i (1866), pp. 223f.; H. Grimm, *Jahrbücher für Kunstwissenschaft*, i (1868), p. 272; JCR Oxford, p. 323; BB 1479; Frey 45, 46; Thode 307; Popp, *Medici-Kapelle*, pp. 159, 161f.; the same, 1925, p. 73; Brinckmann 9 (recto); Tolnay 1928, p. 442, note 56; Tolnay 1930, p. 52; Baumgart 1937, pp. 31ff., 39, 41ff.; Tolnay 1943, pp. 72f., 158f., 187f. (nos. 24 and 25), 212f.; M. Weinberger, *The Art Bulletin*, xxvii, p. 71, note 3; Tolnay 1948, p. 49; Wilde 5; Dussler 162; Hartt 27; BM exh. 1975, no. 6; Tolnay [i] 46.

THE sketch of the Virgin and Child on the recto is a study for the marble group which was acquired directly from Michelangelo by a Flemish merchant, Alexander Mouscron, for the church of Notre Dame in Bruges, where it still is.

The Bruges *Madonna* was completed, and ready for transport to Flanders, by August 1506. Michelangelo must therefore have been working on it at the same time as the *Battle of Cascina* cartoon, and the group of three nude men on the recto is generally, and no doubt correctly, connected with the *Bathers* (see no. 3). The action of the group has been interpreted in two quite different ways. Robinson describes the three figures as "apparently of acrobats"; and this view, that the central figure is being supported in a standing position by his two companions, was followed by Venturi, Berenson, and Thode, all of whom saw in the group a discarded idea for the *Bathers*. (Berenson pointed out that the motif of two men holding up a third in a standing position occurs in a much later drawing in Oxford: Parker 318; Hartt 257.) Brinckmann proposed an alternative explanation, which was accepted by Wilde, Dussler, Hartt, and Tolnay: he saw the man on the left as sitting on the river bank, with his left leg drawn up and

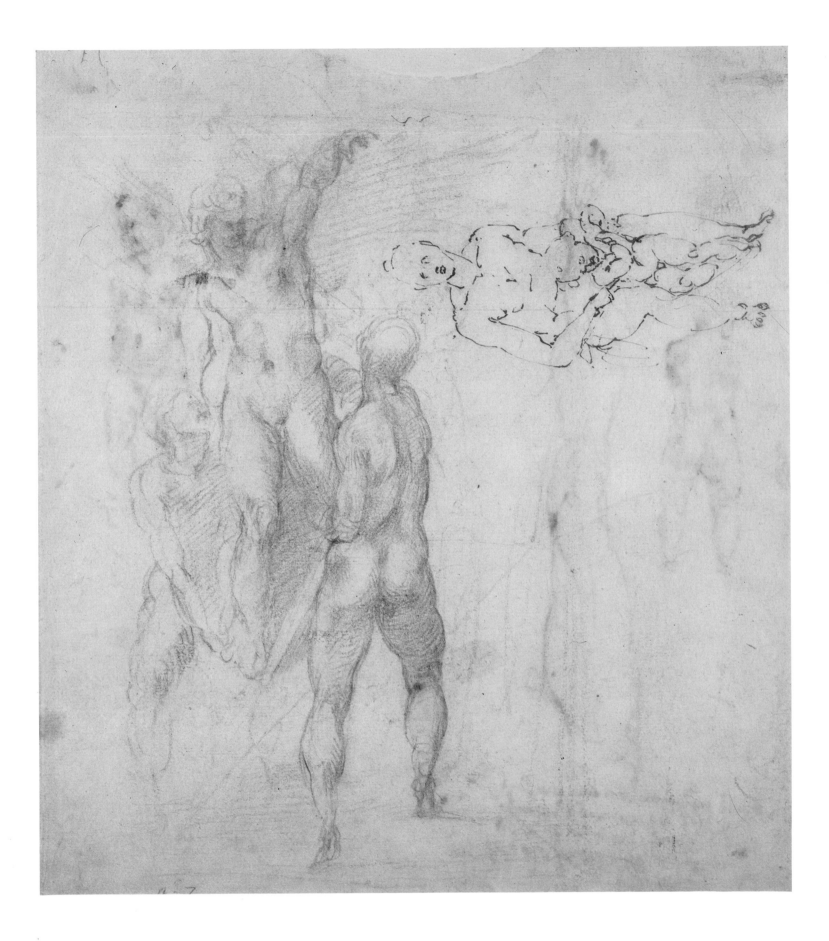

his right leg dangling; the central figure as running down the bank and gesticulating to his comrades still in the river; and the figure on the right as stepping out of the water holding his sword in his left hand.

This interpretation, ingenious though it is, fails to take into account the clear indication of the left leg of the "seated" figure, which shows that he is standing with his legs apart and knees bent as if supporting a heavy weight. What Brinckmann saw as his drawn-up left leg is his down-stretched left arm. And that this interpretation is correct is established, as Berenson pointed out, by a black chalk drawing of the same group in the Louvre (718; BB 1598, 3rd ed., fig. 552; Tolnay [i] 47 recto) in which the action of the figures is clarified: the central figure is standing with his right foot supported in the clasped hands of the left-hand figure and his bent left leg held by his companion on the other side, and is steadying himself by grasping with his right hand the left shoulder of the left-hand figure. In the British Museum sketch the right-hand figure's "sword" seems to be one end of a strip of cloth which the two supporting figures are holding between them to carry the third, in rather the same way as the inert body of Christ is raised in Michelangelo's *Pietà* in the National Gallery in London.

Critical opinion has on the whole tended to reject the Louvre drawing, while accepting as authentic the studies on the verso. But the differences between the group as roughly sketched on the British Museum sheet and fully worked out in the Louvre drawing are so intelligent, and so convincingly rendered, as to exclude any attempt to explain one as a "free copy" of the other. In our opinion, the Louvre drawing is from Michelangelo's own hand; but even if it could be demonstrated to be a copy, it can only be a faithful record of a lost drawing by him.

The black chalk figure on the verso is a sketch for the righthand figure in the recto group. It has been observed that the figures of this group are inspired by Antique statues which Michelangelo would have seen in Rome: the central figure by the Apollo Belvedere and the one on the right by one of the "Horse Tamers" of the Quirinal.

The two studies of children are *en série* with eight similar sketches on the verso of another British Museum sheet (Wilde 4 verso). Two of them are certainly studies for the Infant Baptist in the Taddei *tondo* (Royal Academy, London) while others may be connected with the Bruges *Madonna*.

Inscribed on the lower part of the verso are four lines of a sonnet in pen and six lines in black chalk, now partly indecipherable (see Wilde).

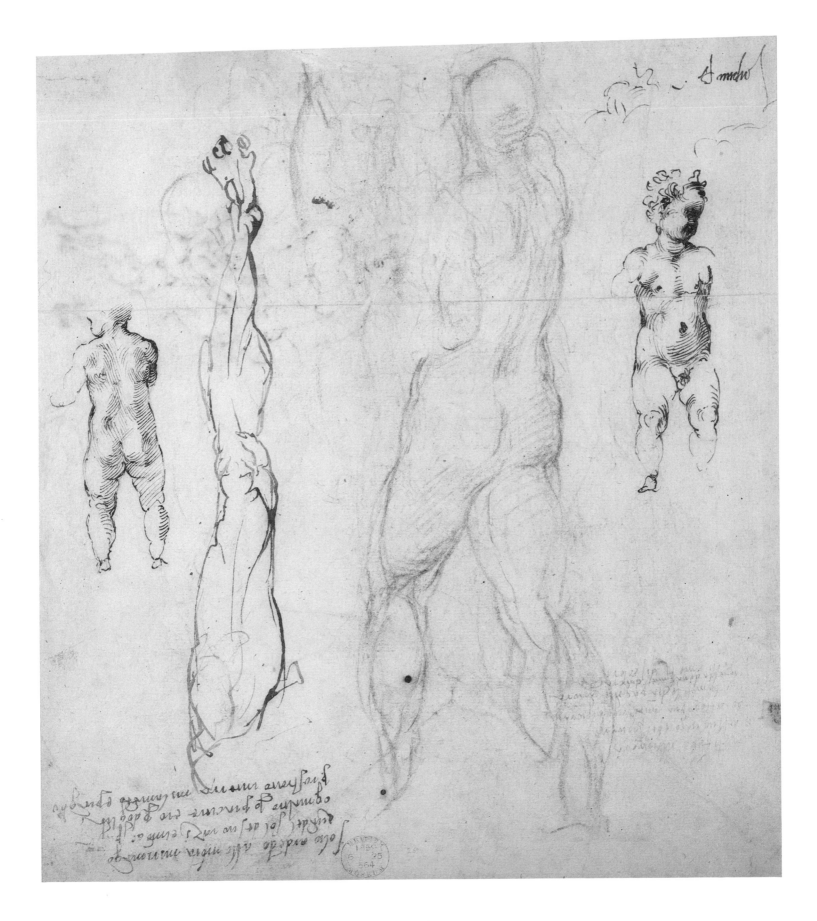

A SEATED NUDE MAN recto.

STUDIES OF NUDE FIGURES AND LEGS verso.

RECTO: pen and brown and greyish-brown ink with some greyish-brown wash, heightened with white. The background to right of the torso shaded in brown wash. VERSO: red chalk.

421: 287 mm. WM: ladder in circle, surmounted by a six-pointed star (JCR *Oxford*, no. 32).

1887–5–2–116

PROVENANCE: Casa Buonarroti and J. B. J. Wicar (according to Lawrence Gallery catalogue); S. Woodburn (sale, Christie's, 1860, 4 June, lot 139, bt, *Tiffin*, £10–10–0); H. Vaughan (L. 1380), by whom presented.

LITERATURE: Lawrence Gallery 42 (pl. 18, recto): J. P. Richter, *Kunstchronik*, xiii (1878), col. 477; BB 1476; W. Köhler, *Kunstgeschichtliches Jahrbuch der k.k. Zentralkommission*, i (1907), p. 156; Frey 103, 164; Thode 335; Vasari Society, 2nd series, ix (1928), 1; Brinckmann 11; E. Panofsky, *Studies in Iconology*, 1939, p. 172; Baumgart 1937, p. 34; Tolnay 1943, pp. 189 (no. 31), 213; Weinberger 1945, p. 72; Wilde 6; Dussler 324, 565; Hartt 41; BM exh. 1975, no. 4; Tolnay [i] 52.

A STUDY for a figure in the center foreground of the composition generally known as the *Bathers*. This was one section, apparently the only one completed, of the cartoon for the *Battle of Cascina*, a painting never executed but intended as a pendant to the *Battle of Anghiari* by Leonardo da Vinci on the other half of one long wall of the Sala del Gran Consiglio in the Palazzo Vecchio (or della Signoria) in Florence. The *Bathers*, which seems to have filled rather less than half the total space allotted to Michelangelo, illustrated an episode in the history of the battle in which a party of Florentine soldiers was surprised while bathing in the Arno by the approach of the enemy. The cartoon exercised a fundamental influence on the first generation of Florentine Mannerists, whose enthusiasm, according to Vasari, was responsible for its eventual dismemberment. The most complete surviving record of the composition is the grisaille at Holkham Hall, which Aristotile da San Gallo painted in 1542, presumably on the basis of a drawing made in his youth.

Michelangelo seems to have chosen this particular episode simply for the opportunity which it offered of representing the male nude in a wide variety of poses. In the words of Sydney Freedberg, "the cartoon, while it survived, replaced the Brancacci Chapel [by Masaccio] as the academy of art, and its matter, in effect, consists of what we call 'academies.' In this incompletely classical, unsynthetic emphasis on formalism and virtuosity Michelangelo anticipates the mentality of the post-classical generation which, indeed, the cartoon later helped to form."

The present drawing, evidently made from a model, is one of the earliest-known

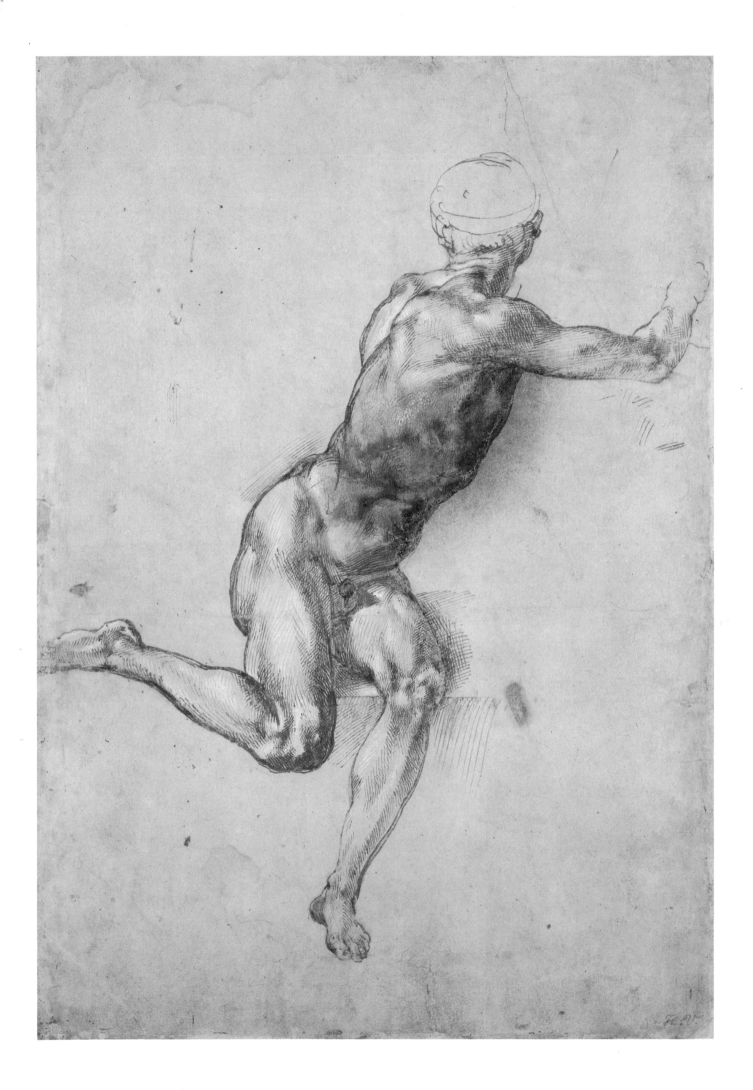

"academic" nude studies. Some critics have been misled by the unusually deliberate character of the modelling into believing that this may be an early copy, but Wilde is surely right in maintaining that it is one of the most outstanding drawings by Michelangelo to have survived "and the surest basis for a reconstruction of the *style* of his lost cartoon."

The studies on the verso are in red chalk, a medium that Michelangelo seems not to have used until the period of the Sistine Ceiling. The discrepancy in date does not necessarily mean that they are not by Michelangelo: for example, the drawing of a Philosopher, which can hardly be much later than *c.* 1500, has on the back a head which is clearly also of the Sistine period (see no. 1). Critical opinion about the verso studies is divided. It may indeed be wondered whether anyone would have ventured to give them to Michelangelo himself if they were not on the same sheet as the recto study. On the whole we agree with Berenson's comment: "I hesitate to say they are not by Michelangelo, although I should prefer to believe they were by a pupil."

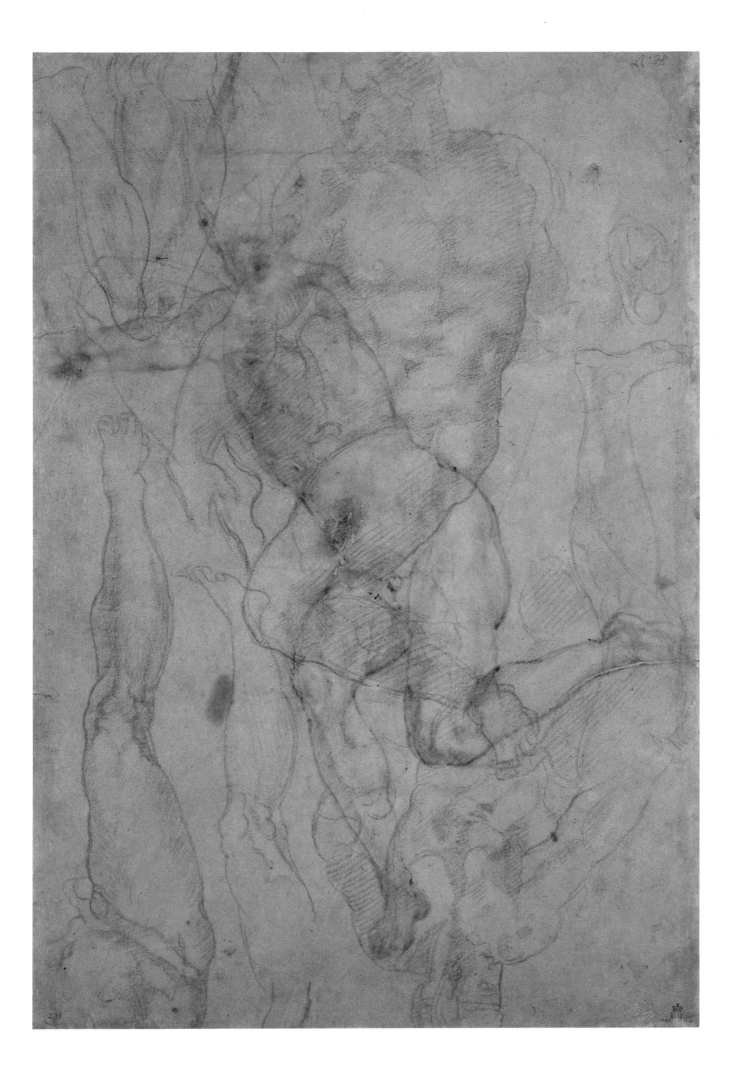

4

SCHEME FOR THE DECORATION OF THE CEILING OF THE SISTINE CHAPEL; FOUR STUDIES OF ARMS recto. TWO SEATED FIGURES (one obliterated); STUDY OF DRAPERY FOR A SEATED FIGURE verso.

RECTO: pen and brown ink over stylus or lead-point (the ceiling study), black chalk (the arms). VERSO: lead-point and point of the brush and brownish-grey wash over charcoal on a lightly blackened surface.

275: 386 mm. WM: eagle displayed in a circle (JCR *Oxford*, no. 1).

1859–6–25–567

PROVENANCE: Casa Buonarroti.

LITERATURE: H. Wölfflin, *Jahrbuch der köninglich preussischen Kunstsammlungen*, xiii (1892), pp. 178ff.; BB 1483; Geymüller, p. 36; Steinmann, pp. 200ff.; Frey 43/44; Thode 310; A. Foratti, *L'Arte*, xxi (1918), pp. 109ff.; J. Gantner, *Monatshefte für Kunstwissenschaft*, xii (1919), pp. 1ff.; E. Panofsky, *Die Sixtinische Decke*, Leipzig, 1921, pp. 4f.; the same, *Jahrbuch für Kunstgeschichte*, i (1921–2), Buchbesprechungen, cols. 35ff.; Brinckmann 21; C. Tolnay, *Bollettino d'arte*, xxix (1935/6), p. 392; Tolnay 1945, pp. 14, 125f., 199 (no. 36: recto), 208 (no. 11A: verso); F. Hartt, *The Art Bulletin*, xxxii (1950), p. 242; Wilde 7; Dussler 163, 318; Hartt 62, 82; BM exh. 1975, no. 14; Tolnay [i] 119.

IN March 1505 Michelangelo was called back to Rome by Pope Julius II and ordered to design the Pope's tomb, to be placed in St. Peter's. His early biographer, Condivi, described the commission as "a tragedy"; it was to overshadow the artist's life for the next forty years, its history a series of compromises by which the design was revised and progressively reduced in order to reconcile the desire of Julius's family for its completion with the more pressing requirements of his successors, Leo X, Clement VII, and Paul III, and even of Julius himself. The first such interruption happened as early as the spring of 1508, when the Pope commissioned Michelangelo to decorate the vault of the Sistine Chapel in the Vatican. Working virtually single-handedly, and with extraordinary speed and concentration, he completed more than half of this enormous task between February 1509 and the end of August 1510, and the entire ceiling by the end of October 1512.

The British Museum drawing and the closely related one in The Detroit Institute of Art are of particular interest in that they provide the only surviving visual evidence of Michelangelo's early ideas for the ceiling. He briefly discussed these plans in two drafts of a letter datable towards the end of 1523 (the relevant passages are printed in Tolnay 1945, pp. 248f.). The decoration was to have consisted of figures of the twelve Apostles "in the lunettes," with the rest of the ceiling divided into compartments "filled with the usual ornament"; but Michelangelo goes on to say that after working out the

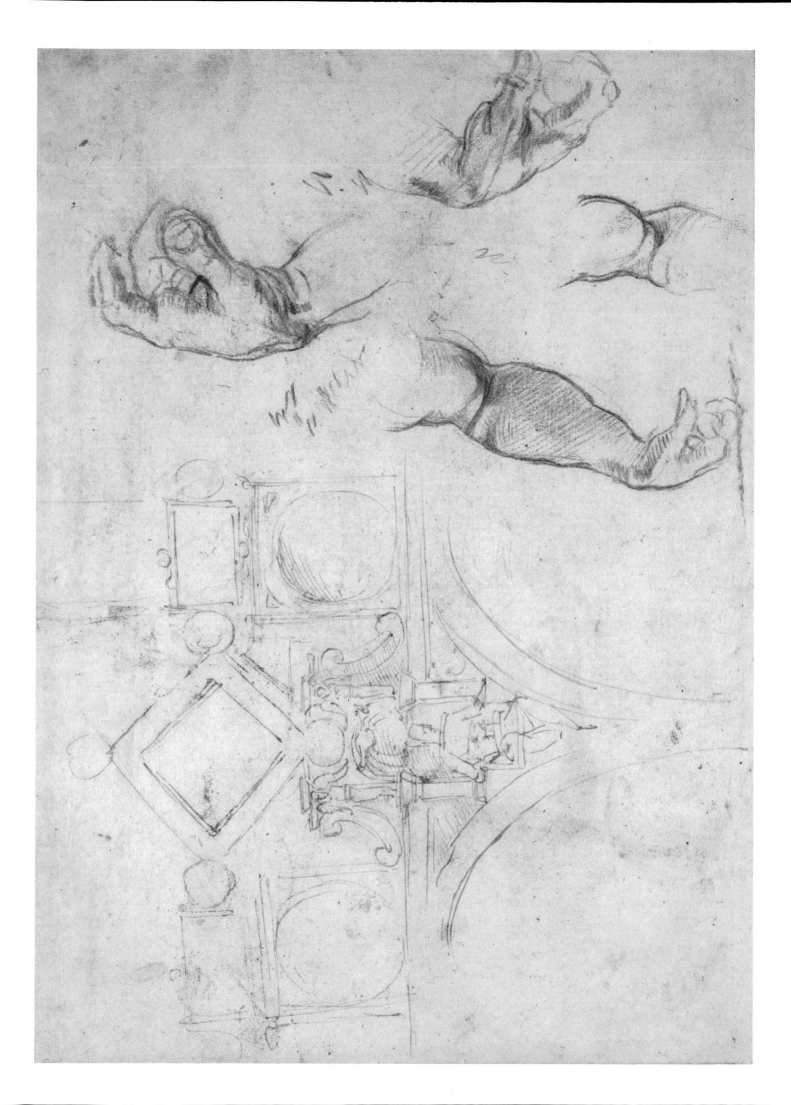

scheme in more detail he found this solution unsatisfactory, whereupon the Pope gave him a new commission, involving about twice as much work. He was to paint the ceiling as he saw fit, going down as far as the "histories underneath," that is, the series of frescoes by Botticelli, Perugino, and others representing scenes from the Old and New Testament which occupy the length of both side-walls of the chapel. (In the event, he did not go down so far, but left untouched the series of standing Popes in niches between the windows, though these are part of the window zone above the cornice and are structurally integrated with the lunettes enclosing the upper part of the windows, which Michelangelo did paint.)

The final scheme was very much more ambitious. Its iconographic programme was devised with reference to the two earlier series of frescoes on the side walls. These illustrate the history of mankind under the Law of the Old Covenant as revealed to Moses, and under the New Covenant as revealed by Christ; the ceiling illustrates the history of mankind in the period before the Old Covenant. The scenes from the Old Testament in the center represent the Creation of Man and the Fall, followed by the Destruction of Mankind in the *Flood* and its salvation in the persons of Noah and his family, ending with the *Drunkenness of Noah* to typify the perpetually unregenerate nature of humanity. The four Old Testament scenes in the corner spandrels, *David and Goliath, Judith and Holofernes, The Crucifixion of Haman,* and *The Worship of the Brazen Serpent,* are instances of God's particular favor towards the Israelites which foreshadow the Redemption, also foreseen by the colossal figures of Prophets and Sibyls in the pendentives of the ceiling. In the lunettes and triangular vaults of the window embrasures are the Ancestors of Christ, which typify the mass of humanity still sunk in darkness.

One of the most conspicuous elements in this complex iconographic scheme are the seated figures of nude youths—the so-called *ignudi*—which flank the *Genesis* scenes in the center of the vault. Their significance has never been satisfactorily explained, though several ingenious suggestions have been made. It is difficult to believe that their function was purely decorative, as some critics (e.g., John Addington Symonds) have maintained, but it is true that Condivi, Michelangelo's contemporary and early biographer, refers to them merely as "certi ignudi."

Michelangelo's mind must still have been filled with his ideas for the Pope's tomb, and it has often been observed that these seem to have found expression in the ceiling, likewise mostly composed of single figures in a complex architectural framework: the colossal Prophets and Sibyls in the spandrels, flanked by plinths decorated with illusionistic sculpture, can be seen as equivalents of the great seated statues (of which the *Moses* was the only one to be executed) which were planned for the upper storey of

the tomb; the *ignudi* as equivalents of the statues of the "Slaves" or "Captives" which were to have stood round the outside of the lower storey; and the scenes in the center of the vault and in the corner spandrels as equivalents of the bronze reliefs of episodes from Julius's life which were to have decorated the uppermost storey.

Michelangelo's reference to the twelve Apostles "in the lunettes" is puzzling, for though there are six lunettes on each side wall, their centers are occupied by the semicircular tops of the windows, so that the space cannot satisfactorily accommodate a single figure; and in fact the *Ancestors* which Michelangelo did paint in the lunettes were arranged in pairs. The explanation can only be that Michelangelo was expressing himself loosely, and intended the Apostles to go in the twelve pendentives of the ceiling, as indeed he has indicated in the British Museum sketch.

The London and Detroit sketches are intimately connected and must be discussed together. Though slight and apparently fragmentary, between them they enable the complete scheme to be understood. In the British Museum sketch, which seems to be the earlier of the two, the sides of the niche in which the figure is enthroned are flat pilasters with capitals formed by projections from the cornice. The upper part of the niche, which penetrates through the cornice into the central field of the ceiling, consists of a semidome in the form of a shell with a circular space above, flanked by winged herms and volutes. The "partimento ripieno d'ornamento come si usa" is a complex pattern of lozenges, circles, and ovals, possibly inspired—as Wölfflin was the first to suggest—by Pinturicchio's painted ceiling in the choir of S. Maria del Popolo, in which figures in niches surround (though they do not impinge upon) a central field composed of a simple arrangement of simple geometric elements. (Another possible source of inspiration, also by Pinturicchio, may have been the very much more intricate patterning of the stucco vault of the Sala del Credo in the Borgia Apartments in the Vatican.) The ingenuity with which Michelangelo has integrated the niche and the ornament, "locking" one into the other by making the subsidiary circle attached to the central lozenge also part of the decoration of the niche, should be noted.

In the Detroit sketch, Michelangelo seems to be halfway towards eliminating the niche, the head of which is pushed down into the pendentive, well below the level of the cornice. The pairs of pilasters remain, but they are now raised above the niche, and are connected by a swag enclosing a ram's skull (if Hartt is correct in his reading of the scribble above the swag). Michelangelo has imposed a more emphatic rhythm on his design for the central field by alternating square spaces containing octagons with narrow bands of more complicated decoration linking the niches on either side of the vault. The niches are integrated into these bands by means of the pilasters, the capitals of which, as in the British Museum sketch, break forward from the cornice

and support pairs of winged *putti* flanking oval frames; between these, in the center of the band, is a rectangular panel in a voluted surround. Michelangelo is here approaching his final solution. He must eventually have come to realise that if the seated figures in the pendentives were to be below the cornice and at the same time large enough in scale to be effective, the cornice would have to be raised and the thrones simplified and enlarged by moving the pilasters further apart. The bands of ornament linking the thrones had correspondingly to be widened, and this he did by widening the lateral strips. The center rectangles remain more or less unchanged and become the smaller Old Testament scenes; the oval frames are reduced to the circular bronze-colored medallions; and the supporting *putti* are enlarged into the *ignudi*. The widening of the bands made the intervening spaces narrower, so that the rhythm is less emphatic but at the same time more subtle.

The separate studies of arms and hands on the two sheets were no doubt made in connection with the ceiling, but they cannot definitely be connected with any particular figure. The seated figure on the verso, partly obliterated with wash, is apparently holding a book in its right hand and is presumably for one of the enthroned Apostles or Prophets. Close to the lower edge and at right angles to it are some very faint and almost indistinguishable rough drawings in stylus, one of which is identified by Wilde as a seated nude figure. The drapery studies on the versos of both sheets seem to be for the *Delphic Sibyl*.

The black chalk torso on the recto of the Detroit sheet is probably for the figure astride the ram in the right foreground of the *Sacrifice of Noah*. The seated figure holding a book attended by a child genius on the verso seems to be a woman of androgynous appearance, as is usual with Michelangelo: if so, this must be an early idea for one of the Sibyls.

5 TORSO OF A SEATED MAN recto. A KNEELING NUDE MAN AND THREE SEATED NUDE MEN verso.

RECTO: soft black chalk. VERSO: pen and yellowish-brown ink over lead-point (the kneeling figure), pen and brown ink (the seated figures).

188: 245 mm. WM: JCR *Oxford*, no. 34.

1859–6–25–568

PROVENANCE: Casa Buonarroti.

LITERATURE: H. Wölfflin, *Jugendwerke des Michelangelo*, Munich, 1891, p. 32; BB 1484; Steinmann 2, 5; Frey 122, 121; Thode 311; Brinckmann 34 (verso); F. Kriegbaum, *Jahrbuch des Kunsthistorischen Sammlungen in Wien*, N.S., iii (1929), pp. 250f.; Tolnay 1945, p. 201 (no. 41: verso); Wilde 8; Dussler 319, 164; Hartt 100, 96; BM exh. 1975, no. 15 (verso); Tolnay [i] 139.

THE three sketches of seated nude figures on the verso are clearly early ideas for the *ignudi* on the Sistine Ceiling, though they were never carried out. (The two lower ones resemble most closely the two figures above *Joel*; so far as the position of the legs is concerned, the upper sketch resembles in reverse the figure to the right above *Daniel*.) The torso on the recto is a study for the *ignudo* to the right above the *Delphic Sibyl*.

The placing of the verso sketches suggests that the figure on the left, which is in a lighter ink applied with a finer pen, was drawn before the other three. As first drawn in black chalk, the figure kneels on its right knee, but Michelangelo when elaborating the drawing in pen has also made him kneel on both knees. The figure is derived from an Antique prototype. Its proximity to the other sketches led Wilde to suggest that there may have been a phase in the design of the ceiling in which the *ignudi* were to have been kneeling rather than seated.

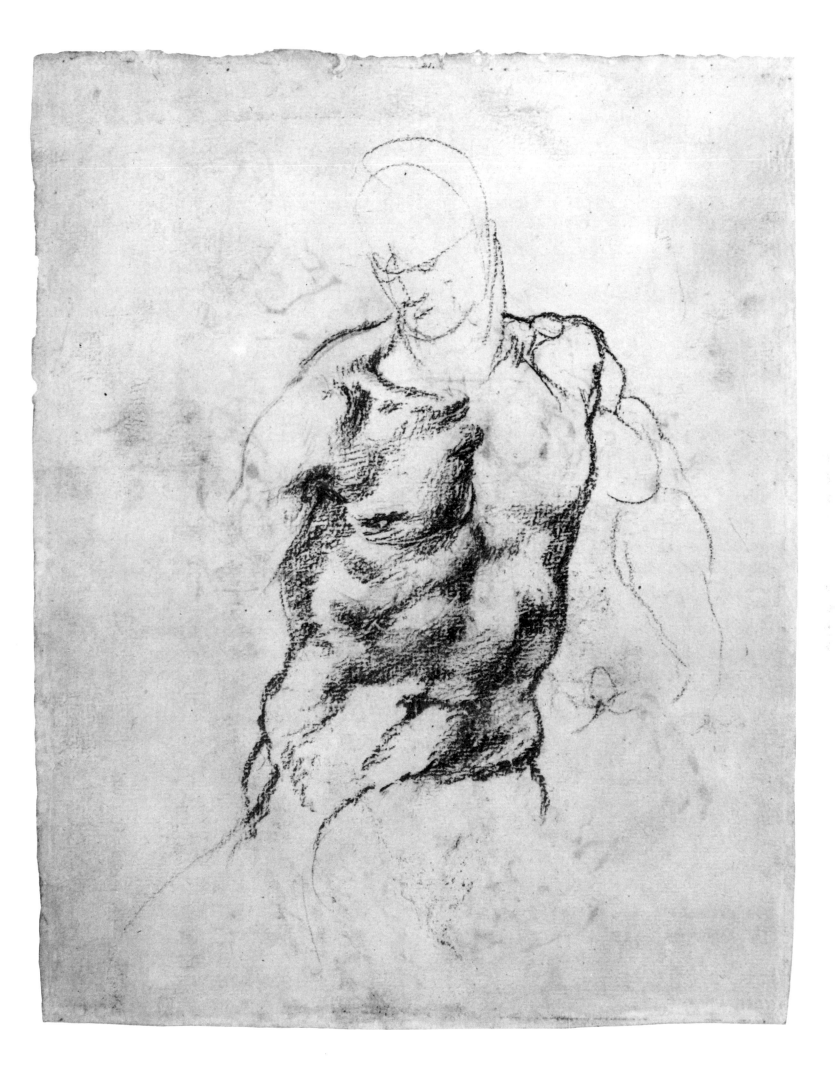

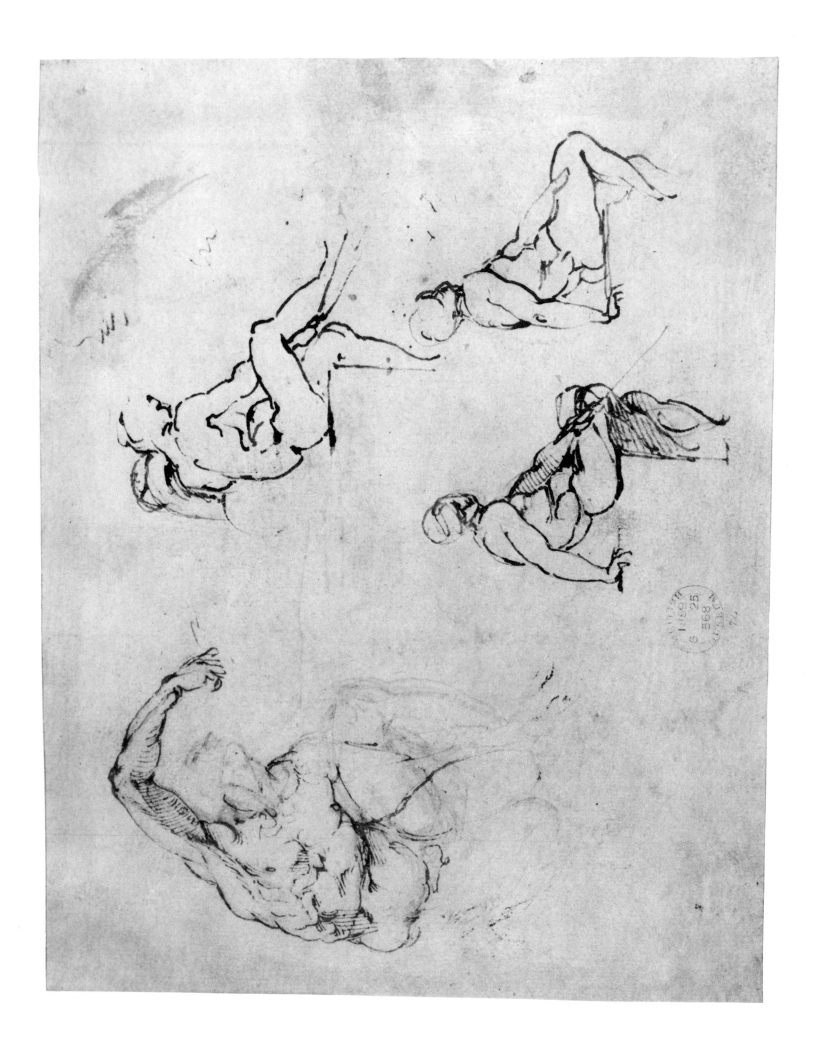

6 STUDY OF DRAPERY FOR A SEATED FIGURE recto.
A SIBYL; SCHEME FOR A CEILING; AND A
LEFT HAND verso.

RECTO: black chalk and pen and dark ink over a brush drawing in brown ink; the black chalk is used only for part of the outline of the nude. VERSO: two sorts of chalk seem to have been used: a grey-brown for the Sibyl and the scheme, and a black for the hand. All three sketches are considerably rubbed and the brown wash shows through from the recto.

387: 260 mm. WM: JCR *Oxford*, no. 40. The right lower corner torn away and mended; several patches in the top right corner, the largest occurring in the middle of the hand on the verso.

1887–5–2–118

PROVENANCE: Casa Buonarroti; J. B. J. Wicar (according to Lawrence Gallery); Sir T. Lawrence (L. 2445); S. Woodburn (sale, 1860, 4 June, lot 147, bt, *Evans*, £5–5–0); H. Vaughan, by whom presented.

LITERATURE: Lawrence Gallery 12 (pl. 21, recto); BB 1485; Steinmann 42; Frey 94, 93; Thode 337; C. Tolnay, *Bollettino d'arte*, xxix (1935/6), pp. 392, 405; B. Biagetti in *Nel IV Centenario del Giudizio Universale*, Florence, 1942, p. 196; Tolnay 1945, pp. 15, 126, 200 (no. 38); Wilde 10; L. Goldscheider, *Michelangelo Drawings*, London, 1951, p. 180; Dussler 566; Hartt 84; BM exh. 1975, no. 17; Tolnay [i] 154.

THE study of the recto is for the drapery of the Erythraean Sibyl, which in the fresco is considerably simplified. Wilde is no doubt right in seeing this as an example of the characteristic Florentine technique of making such studies, described by Vasari in his life of Leonardo (iv, p. 20): the drapery was arranged on a small model of the figure and dipped in liquid clay which was allowed to harden. There can equally be no doubt that he is right in maintaining that the entire drawing is by Michelangelo. The deliberate building-up of the sculptural form by a complex system of hatching and cross-hatching can be seen in embryo even in such very early drawings as the *Philosopher* (no. 1).

Thode and Berenson, influenced no doubt by the unfamiliar appearance of the drawing, saw it as largely reworked; Goldscheider, misled by its superficial resemblance to a study of the same type at Windsor in which the emphasis is equally on the drapery with the figure only lightly sketched, attributed it to Taddeo Zuccaro(!), an opinion which Dussler seems inclined to favor. Hartt and Tolnay follow Wilde.

The roughly sketched figure on the verso is a study for the pose of the same Sibyl, differing from the painted version in the position of the arms. The plan near the upper edge is a summary outline of the ceiling, indicating the position of the Prophets and Sibyls. Wilde was the first to observe that the hand corresponds with that of one of the daughters-in-law in the *Sacrifice of Noah*.

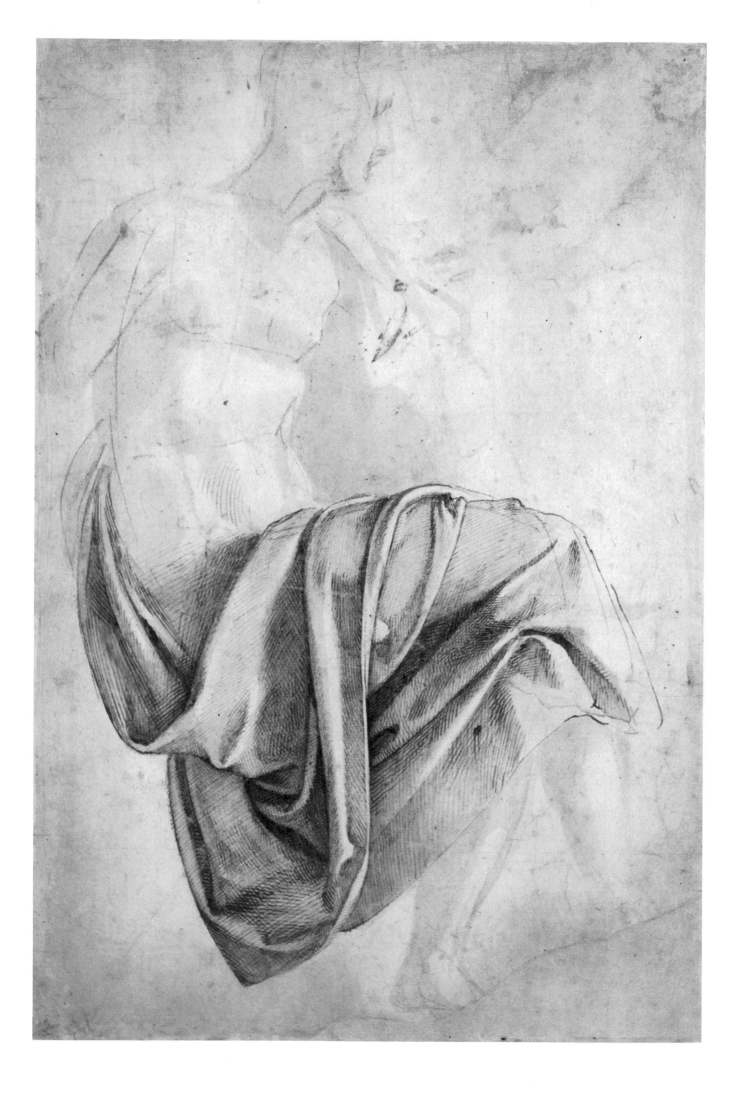

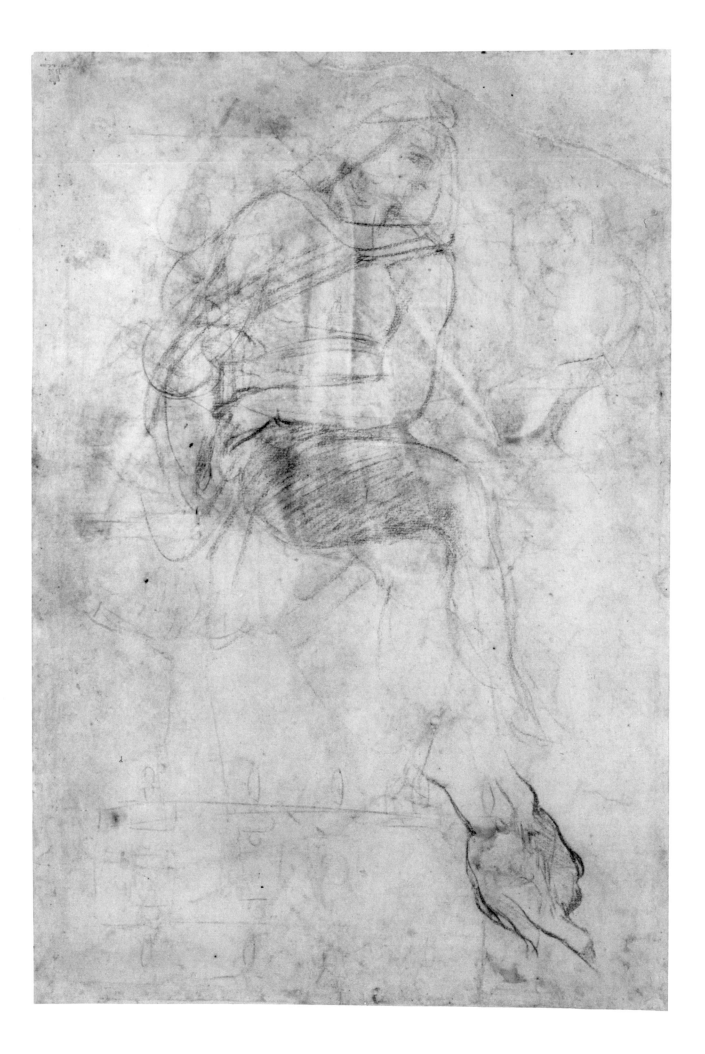

7 STUDIES OF A RECLINING MALE NUDE recto.

HEAD OF A YOUTH verso.

Red chalk. Touches of (oxidized) white heightening in four places on the verso. The outline of the head of the verso was intermittently traced with a sharp instrument and in some places cut right through, and mended. Wilde claims that the recto "was at some later period varnished, and this has altered the colour of the chalk," but scientific examination of the paper reveals no trace of such treatment.

193: 259 mm. WM: JCR *Oxford*, no. 28. The sheet has been torn in two places and trimmed on all sides. Little holes have been repaired in several places.

1926–10–9–1

PROVENANCE: J. Richardson senior, Sir J. Reynolds and W. Y. Ottley (according to Lawrence Gallery catalogue); Sir T. Lawrence (L. 2445); S. Woodburn (sale, 1860, 4 June, lot 100, bt, *Tiffin*, £42–0–0); Frederick Locker (later Locker-Lampson, d. 1895; in his possession by 1868, the date of Cruickshank's etching, *Fairy Connoisseurs inspecting Mr Frederick Locker's Collection of Drawings, etc. etc.* [Reid 2654], in which this drawing is represented); Mrs. F. Locker-Lampson. Presented by the National Art Collections Fund with the aid of contributions from Sir Joseph Duveen and Henry van den Bergh, Esq.

LITERATURE: Ottley 28, 29; Lawrence Gallery 79; JCR *Oxford*, p. 41; BB 1519A (no. 1746A in the first edition); Steinmann 33, 12; Thode 517; L. B[inyon], *Vasari Society*, second series, vii (1926), 8; E. Panofsky, *Repertorium*, xlviii (1927), p. 37, note 1; M. Delacre, *Burlington*, lxvi (1935), pp. 278f., and lxvii (1935), pp. 137f.; A. E. Popham, ibid., pp. 44f.; Tolnay 1945, p. 207 (no. 6A); Wilde 11; Dussler 580; Hartt 77; BM exh. 1975, no. 18; Tolnay [i] 134.

THE drawing on the recto poses a particularly difficult problem of connoisseurship. The balance of critical opinion is in its favor. Robinson, Thode, Wilde, Hartt, and Tolnay accept it as a study by Michelangelo for the figure of Adam in the *Creation of Adam* on the Sistine Ceiling. Dussler rejects it. Wilde oversimplifies Berenson's position by implying that he rejected the drawing in his first edition and accepted it in his second. It is true that Berenson promoted the drawing from "School of Michelangelo" to "Michelangelo," but he did so only after much heart-searching, at the end of which he was obliged to admit that he was still undecided whether it is an original or an unusually accomplished contemporary copy of a lost drawing.

In spite of the impressive provenance of the drawing, and the impressive weight of critical opinion in its favor, we find ourselves inclined to sympathize with Berenson's hesitation. Two sheets of studies for the same fresco, likewise in red chalk, are in Haarlem (A27 verso and A20: Hartt 74, 75/6). Particularly characteristic in these is the emphatic and springy contour, the area of rapid even parallel hatching to denote tone rather than form, and the expressiveness of the hands, however sketchily suggested.

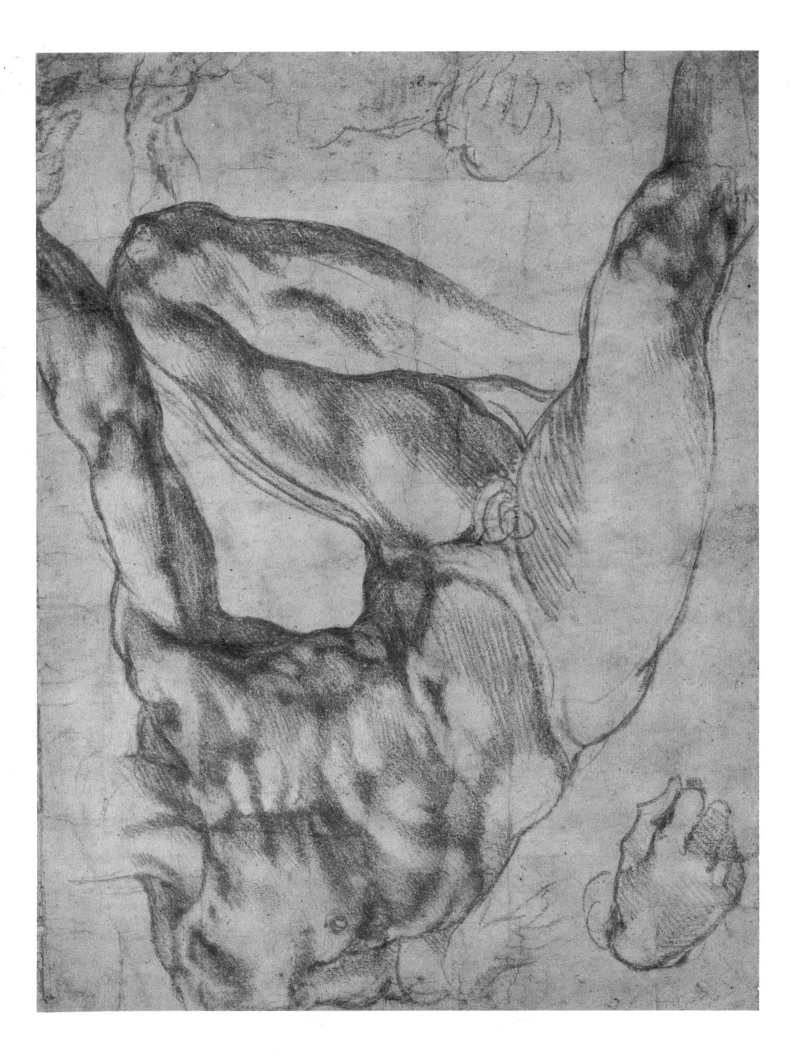

By contrast, the contours of the British Museum figure seem flaccid and without accent, and the internal modelling lacking in rhythm.

A faithful copy of this drawing (or of the lost original) is in the Louvre (RF28961: rep. Tolnay, i, p. 205); according to Berenson there is another in the Musée Ingres at Montauban.

The head on the verso is connected with the *ignudo* to the left above the Persian Sibyl. Wilde, who points out that the head in the fresco is much idealized, considers that the drawing is a study made from the life. Hartt accepts it, as does Tolnay, though with some reluctance.

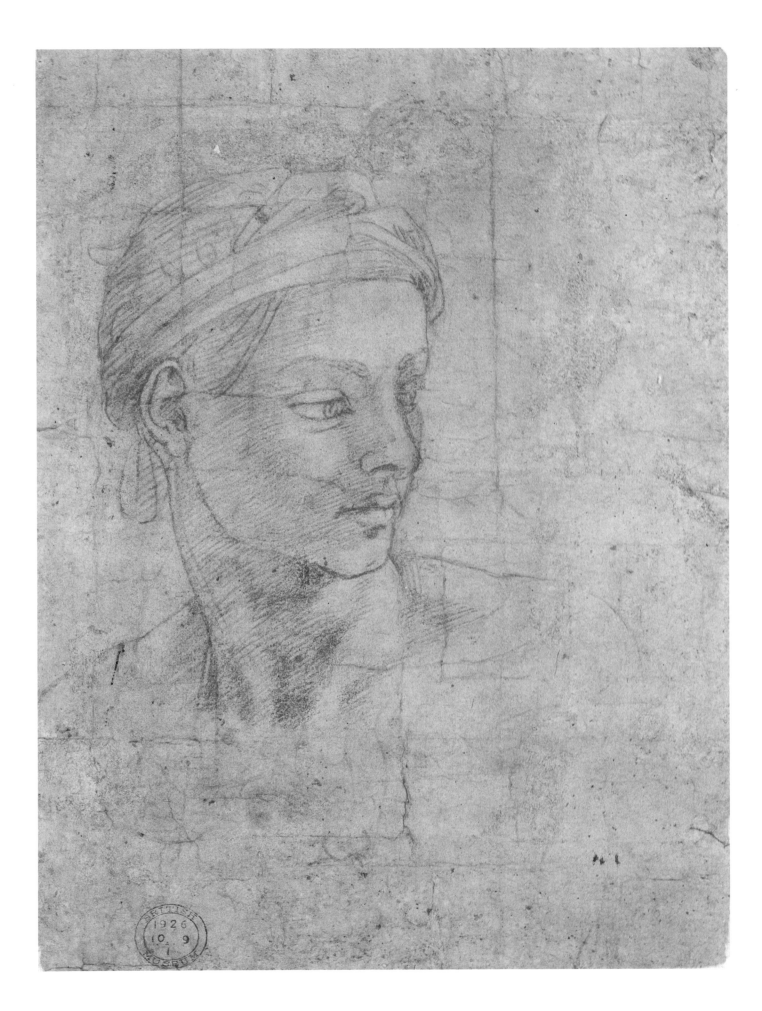

8 CHRIST AT THE COLUMN

Black chalk, with some stumping, over stylus underdrawing. Heightened with chalk.

275: 143 mm.

1895–9–15–813 (placed as Wilde 15a)

PROVENANCE: Cicciaporci?; W. Y. Ottley? (perhaps lot 828 in his sale, London, T. Philipe, 1814, 13 June: "Michelangelo: The figure of Christ naked, *for the flagellation, painted by S. del Piombo—black chalk, stumped and heightened—very fine*. From The Cicciaporci collection"); Sir T. Lawrence (L. 2445; probably identical with Lawrence Gallery 51; measurements and medium agree, but the drawing is said to have come from the Richardson Collection and there is no trace of the collector's marks of either of the Richardsons on no. 8; on the other hand, Lawrence Gallery 51 is listed in Woodburn's memorandum, of which there is a copy in the Ashmolean Museum, as being one of the drawings bought by the King of Holland); King William II of Holland (sale, The Hague, 1850, 12 August etc., lot 179, bt, *Roos, 70 fls*); G. Leembruggen (sale, Amsterdam, 1866, 5 March etc., lot 894); John Malcolm of Poltalloch (bt at the Leembruggen sale for £14–7–11); purchased with the Malcolm Collection in 1895.

LITERATURE: JCR 366; BB 2488; Loeser 1897, p. 354; P. d'Achiardi, *Sebastiano del Piombo*, Rome, 1908, pp. 321f.; Tolnay 1928, pp. 76f.; L. Dussler, *Sebastiano del Piombo*, Basle, 1942, pp. 96, 169, no. 156; R. Pallucchini, *Sebastian Viniziano*, Milan, 1944, pp. 52f.; Tolnay 1948, pp. 19f.; Wilde, pp. 28f.; P. Pouncey and J. A. Gere, *Italian Drawings in the Department of Prints and Drawings in the British Museum: Raphael and His Circle*, London, 1962, no. 276; S. J. Freedberg, *The Art Bulletin*, xlv (1963), pp. 254ff.; BM exh. 1975, no. 38; Tolnay [i] 74.

THIS drawing and no. 9 belong to a group that continues to provoke controversy. They are preliminary studies for two paintings by Michelangelo's Venetian friend and protégé Sebastiano del Piombo: *The Flagellation of Christ* in the Roman church of S. Pietro in Montorio and *The Raising of Lazarus* now in the National Gallery in London. No. 8 is a study for the figure of Christ at the Column in the *Flagellation* and no. 9 is for the group of Lazarus and his supporters. A composition-sketch for the *Flagellation* and another study for the group with Lazarus are also in the British Museum (Wilde 15 and 17 respectively), and a third study for the group with Lazarus is in the Musée Bonnat at Bayonne (BB 2474C: Bean cat. no. 65).

The study for the Lazarus group here exhibited (Wilde 16) finds its place between those on the Bayonne sheet and Wilde 17. The vertical framing line indicated on the right of the latter corresponds with the right-hand edge of the panel and shows that the design of the whole composition had been determined when the sketch was made. The group in the painting is a combination of the two British Museum studies: Lazarus and the figure standing behind him are as in Wilde 17; the kneeling figure on the right as in Wilde 16.

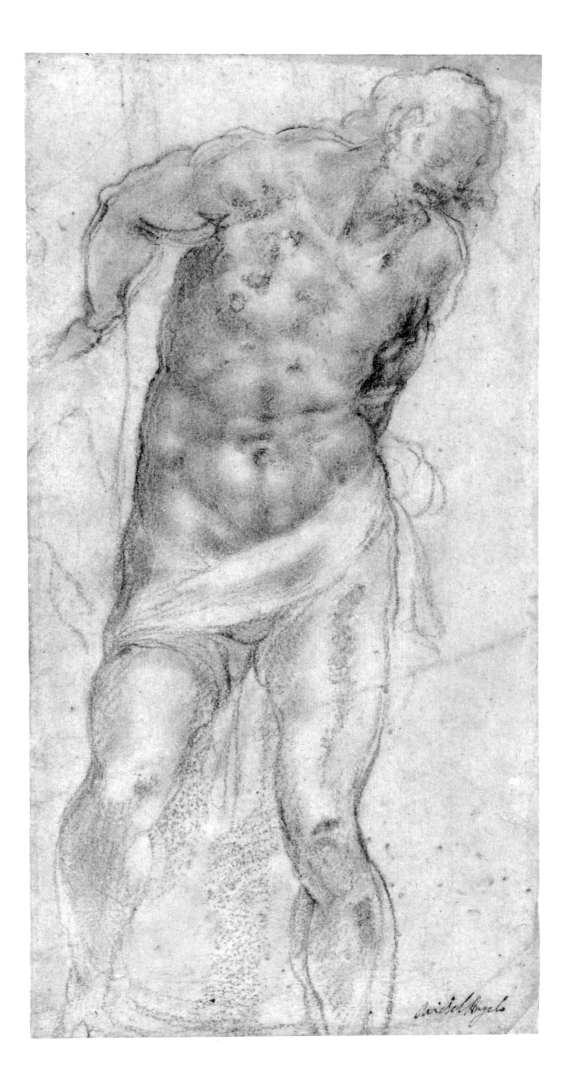

Connection with an authenticated work is normally one of the most certain ways of establishing a drawing's authorship. But in this case the problem is complicated by the fact that Michelangelo is on record as having had a share in the design of both compositions. Vasari describes three commissions which Sebastiano del Piombo received in about 1515–16, in all of which he was assisted by Michelangelo. The first was the Viterbo *Pietà* "con molta diligenza finito da Sebastiano, che vi fece un paese tenebroso molto lodato, l'invenzione però ed il cartone fu di Michelangelo." This was followed by the *Flagellation*, commissioned on Michelangelo's recommendation by Francesco Borgherini for his chapel in S. Pietro in Montorio on the understanding "come fu vero, che Michelangelo dovesse far egli il disegno di tutta l'opera." A letter from Michelangelo establishes that his final design for the composition (lost, but known from a copy by Giulio Clovio at Windsor: Popham-Wilde no. 451, fig. 100) arrived in Rome in August 1516. The third commission, given towards the end of the same year by Cardinal Giulio de' Medici, nephew of the reigning Pope Leo X and himself elected Pope in 1523 as Clement VII, was for the large altarpiece of *The Raising of Lazarus* intended for the Cardinal's cathedral of Narbonne in southern France, "dipinta con diligenza grandissima, sotto ordine e disegno in alcune parti di Michelagnolo." No drawings for the Viterbo *Pietà* are known, but there is a black chalk study of a Dead Christ, in the Louvre (716; BB 1586; Hartt 454), which corresponds with the figure in Sebastiano's Ubeda *Pietà* of some twenty years later. Though Vasari makes no mention of Michelangelo in connection with this picture, the drawing was traditionally attributed to him and should be considered together with those connected with works in which Michelangelo is recorded as having collaborated with Sebastiano.

The problem can be briefly stated: are these drawings by Michelangelo, as was traditionally believed; or are they, as some critics still maintain, by Sebastiano?

Sebastiano Luciani, usually called by the title of the sinecure office of Superintendent of the Sealing ("Piombo") of the Papal Briefs to which he was appointed in 1531, was born in about 1485 in Venice, where he was a pupil first of Giovanni Bellini and later of Giorgione. In 1511 he came to Rome at the invitation of Raphael's patron Agostino Chigi; but, after briefly collaborating with Raphael in the decoration of Chigi's house (the Villa Farnesina), he attached himself to Raphael's rival Michelangelo. The professional jealousy of these two great artists, which divided the artistic world of Rome in the second decade of the sixteenth century, was exacerbated by a temperamental incompatibility which amounted to open hostility. Michelangelo differed essentially from Raphael in being a solitary genius. Raphael's lucidly analytical intelligence enabled him to plan his work so that as much as possible could be delegated to an ef-

ficiently organized studio. Michelangelo's thought was incommunicable; and though the number and scale of the commissions that he undertook obliged him to employ assistants, the only help that they were able to provide was mechanical and uncreative. At various times, however, one or two independent followers attached themselves to him, whose projects he was prepared to assist by making drawings. In this way he was able to give vicarious expression to ideas which might otherwise have been stifled by the pressure of more urgent commitments. Of these followers, Sebastiano was the first and the most important; and Michelangelo would have been all the more willing to help him since one of his three commissions—*The Raising of Lazarus*—involved a direct confrontation with Raphael, whose equally large altarpiece of *The Transfiguration* was commissioned at the same time, by the same influential patron, also for the cathedral at Narbonne.

The theory of Sebastiano's authorship of these drawings and, by attraction, of others traditionally believed to be by Michelangelo, is beginning to lose ground; most students today will probably agree with Kenneth Clark's description of it as "one of the heroic curiosities of connoisseurship." But as an example of the methodology of connoisseurship it may be of interest to trace its history. It was first argued in detail around the turn of the last century by two exceptionally gifted connoisseurs of Italian drawings, Franz Wickhoff and Bernard Berenson, and one's natural instinct would be to explain it as a consequence of the overenthusiastic application of the method of "scientific" connoisseurship initiated in the 1870s by Giovanni Morelli. But in fact the name of Sebastiano had been proposed for some of these drawings even before the middle of the century.

All six drawings—the two connected with *The Flagellation*, in the British Museum; the three studies for *The Raising of Lazarus* in the British Museum and at Bayonne; and the Louvre *Dead Christ*—bear the collector's mark of Sir Thomas Lawrence; and all six can be identified among the selection of one hundred Michelangelo drawings which constituted the last of the ten exhibitions collectively entitled "The Lawrence Gallery," organized in 1836 by the London dealer Samuel Woodburn in an attempt to dispose of the collection which had passed to him, as principal creditor, after Lawrence's death in 1830. Michelangelo's authorship was accepted without question in the catalogue, where it was also stated that all but one of the six—the British Museum *Christ at the Column*—had been acquired by the French collector J. B. J. Wicar from Michelangelo's collateral descendants, the Buonarroti family. In 1838, fifty-nine of the hundred Michelangelo drawings exhibited, including all six of the group under consideration, were bought from Woodburn by King William II of Holland.

The confusion between Michelangelo and Sebastiano makes its earliest appearance

in the comment on no. 43 in the Lawrence Gallery catalogue, the study by Sebastiano, now in Frankfurt, for the figure of Martha in *The Raising of Lazarus*: "this drawing . . . illustrates, in a great degree, the idea always entertained of the share M. Angelo had in this grand picture. It has evidently been executed by S. del Piombo, probably from some sketch by M. Angelo, and has been shown to him for his approval. He has left the head as it was; but has enlarged the style of the drapery, and sketched in, with wonderful energy, some heads in the background." The sale catalogue of the King of Holland's collection, dispersed in The Hague in August 1850, shows that the confusion had increased in the intervening fourteen years. The composition-sketch for *The Flagellation* appeared under the name of Sebastiano (lot 126), but the study of *Christ at the Column* (without reference to the Borgherini painting, though the connection had been pointed out in the Lawrence Gallery) as by Michelangelo (lot 179). Both drawings were bought by the Dutch collector Gerard Leembruggen. Of the three studies in red chalk for *The Raising of Lazarus* (lots 130, 131, and 167), which are described in so summary a fashion that they cannot be identified individually, two were given to Sebastiano and one to Michelangelo. All three were bought back by Woodburn. The Louvre *Dead Christ* (lot 118) and the Frankfurt *Martha* (lot 151) were both attributed to Michelangelo. Whoever was responsible for cataloguing the drawings in this sale was evidently a literally minded person, obsessed, in defiance of any evidence to the contrary, by the "commonsense" view that the executant of a painting must have been responsible for any preliminary studies. (It is significant that the drawings of *Christ Expelling the Money-Changers* [see no. 23] and *The Annunciation* [see no. 22], appear in the catalogue under the name of Marcello Venusti: the cataloguer had evidently taken to heart the information in the Lawrence Gallery catalogue that Venusti had produced paintings of both compositions.)

The British Museum acquired its two *Lazarus* studies at the Woodburn sale in 1860, in which all three were attributed to Michelangelo; the two drawings for the *Flagellation* came in 1895 as part of the collection of John Malcolm of Poltalloch, who had acquired them at the Leembruggen sale in 1866. Malcolm's expert adviser J. C. Robinson, one of the greatest of English connoisseurs, compiled a catalogue of his collection, the first edition of which appeared in 1869. Robinson there interchanged the attributions which the two drawings had borne in the King of Holland and Leembruggen sales, giving the composition-sketch to Michelangelo and the *Christ at the Column* to Sebastiano. It is particularly regrettable that this difficult question should have happened to fall outside the scope of the masterly catalogue of the Oxford Michelangelos which he published in 1870, for in the Malcolm catalogue he makes no attempt to discuss it or to justify his conclusions. But it seems probable that in attrib-

uting to Sebastiano the *Christ at the Column*, in which the figure is on a very much larger scale than in the composition-sketch, he was influenced by Vasari's statement that "dal piccolo disegno di Michelangelo, ne fece [Sebastiano] per suo comodo alcun'altri maggiori"—a not unreasonable conclusion in the 1860s, when Sebastiano's individual personality as a draughtsman was unknown and the extent to which his drawing style was influenced by Michelangelo still a matter of conjecture.

In 1897, the British Museum's exhibition of the recently acquired Malcolm Collection was reviewed by Charles Loeser. He accepted as self-evident Robinson's attribution of the *Christ at the Column* to Sebastiano, and added to it the composition-sketch for the *Flagellation*. He did not justify this conclusion in detail, beyond asserting that the drawing "bears the imprint of the Venetian School, and more especially that of Sebastiano's Roman style. . . . Though Vasari tells us that Michelangelo made a drawing for Sebastiano's painting in S. Pietro in Montorio, we have here the proof that it was Sebastiano who made the drawing that comes closest to the picture." This brief paragraph epitomizes many characteristics of the arguments that later critics were to expand: the tendency to discuss problems of authorship in general terms such as "Tuscan" or "Venetian"; the tendency to argue in a circle; and the tendency to brush aside the testimony of Vasari.

In 1899 Wickhoff added to the group the two Lazarus studies in the British Museum (the third was then in the collection of Leon Bonnat), the British Museum *Three Crosses* (Wilde 32), and the Windsor *Virgin and Child* (Popham-Wilde, no. 426). Four years later appeared the first edition of Berenson's *Drawings of the Florentine Painters* in which the group was greatly enlarged—the additions included the "Warwick *Pietà*" (no. 19 in the present exhibition)—and the case for Sebastiano's authorship eloquently defended. Wickhoff and Berenson were both disciples of Morelli, but their master, who died in 1891, seems not to have been involved in this particular controversy. Berenson indeed claims his support for attributing to Sebastiano the earlier of the two Lazarus studies (Wilde 16), but this can hardly have been so: in a posthumously published note (*Kunstchronik*, N.S., iii [1891-2], col. 525), consisting of a series of laconic comments on a group of recently issued Braun photographs, Morelli lists what is clearly this drawing rather than Wilde 17 under the name of Michelangelo, and, after noting that it was drawn to help Sebastiano, adds the one word "echt," indicating that he accepted Michelangelo's authorship.

"Such a man as Scaliger, living in our time, would be a better critic than Scaliger was; but we shall not be better critics than Scaliger by the simple act of living in our own time": A. E. Housman's words should be remembered whenever we are tempted to profit by hindsight in order to criticize our predecessors. Wickhoff and Berenson

were the great pioneers who first attacked the daunting problem of reducing to order a vast mass of ill-classified and misattributed material, and by so doing laid the foundation of all subsequent connoisseurship in the field of Italian drawings. It is the fate of such pioneers that when they are right—as these usually were—their findings now seem so obvious as to be taken for granted; while their mistakes—and with critics so wide-ranging some mistakes are inevitable—become increasingly conspicuous. If we put ourselves in their place we can easily imagine how hard it would have been, at a time when the Morellian "method" was sweeping all before it and achieving such remarkable results, to resist the appeal of a theory so revolutionary, so brilliant, and to all appearances so plausible. At the same time it cannot be denied that Wickhoff and (at that stage) Berenson approached the problem without having made any attempt to form a positive conception of Sebastiano's personality as a draughtsman. Wickhoff cleared the ground for conjecture by declaring that no drawings certainly by Sebastiano are known, and that "wir . . . müssen von neuen beginnen." A page or so later he contradicts this sweeping statement by a passing reference which, though vaguely worded, must be to the Louvre study for the S. Maria della Pace *Visitation* (BB 2497). Indeed, as Michael Hirst pointed out to me, it would not have been difficult even in the 1890s to assemble a nucleus of drawings attributable to Sebastiano without confusion with Michelangelo: the study for Martha in the *Raising of Lazarus* (which Wickhoff does not mention, even to attribute it to Michelangelo) had been in the Städel Institut in Frankfurt since 1850; the Chatsworth study for one of the Apostles in the Borgherini Chapel (BB 2478) had been photographed by Braun in the 1860s; and in 1879 Braun photographed the *Virgin and Child* then in the Gatteaux Collection and now in the École des Beaux-Arts (BB 2499), where it had been exhibited in the same year under the correct attribution with a note in the catalogue connecting it with the *Madonna del Velo* in Naples (in fact it is for the *Virgin and Child* at Burgos).

Berenson, having admitted that the inclusion of a Veneto-Roman painter in a work devoted to Florentine drawings was an anomaly and that he approached Sebastiano merely as an *alter ego* of Michelangelo, began his attempt to define the artist's drawing style by assuming what he was setting out to prove, and took as the starting point of his reconstruction the later of the two *Lazarus* studies in the British Museum "now accepted by all serious critics." Even in his revised edition of 1938 he reveals an uncertain grasp of Sebastiano's personality, for under that name are drawings by artists as disparate as Pordenone (BB 2490), Siciolante da Sermoneta (BB 2500A), and Figino (BB 2492).

Pietro d'Achiardi, the first critic to undertake a full-scale monograph on Sebastiano, followed Berenson in attributing to him the two *Lazarus* studies in the British Museum

(he does not mention the third, now at Bayonne) and both those for the *Flagellation*; also the Louvre *Dead Christ*, which he had been the first to connect with the Ubeda picture. Five years later appeared Henry Thode's invaluable catalogue of Michelangelo's drawings. It is to Thode's credit that he refused to be stampeded by the Sebastiano hypothesis, which he found himself unable wholeheartedly to accept: he retained under the name of Michelangelo the earlier of the British Museum *Lazarus* studies (Wilde 16) and the Bayonne sheet (curiously enough, he does not even refer to the *Raising of Lazarus* in his discussion of the latter, which he was inclined to connect with the *ignudi* on the Sistine Ceiling); to Sebastiano he gave the third *Lazarus* study (Wilde 17) and the composition-sketch for the *Flagellation* (with the reservation that the figure of Christ may have been copied from a drawing by Michelangelo or even retouched by him); he does not include the *Christ at the Column* or the *Dead Christ*, so presumably he took for granted Sebastiano's authorship of both.

In 1927 Erwin Panofsky (*Festschrift für Julius Schlosser*, Vienna, pp. 150ff.) published the Louvre *Dead Christ* together with a black chalk sketch in the Casa Buonarroti for the torso and arms of the same figure (69[F]: Hartt 453), and after comparing the two in detail concluded that the latter was by Michelangelo and the former by Sebastiano. Panofsky was a great scholar, of massive erudition and exceptional subtlety of mind, but this judgment of his must be assessed in the light of his simultaneous pronouncement (*Old Master Drawings*, ii [1927/8], p. 33) that the large-scale *modello* in the Louvre for the S. Maria del Popolo *Birth of the Virgin*—a drawing which has been either ignored or dismissed in all the literature on Sebastiano, but in which there are many passages that reveal his hand at its most characteristic—is a variant produced in the studio of Francesco Salviati.

By 1938, when the second edition of Berenson's *Florentine Drawings* appeared, Sebastiano's personality as a draughtsman had come into sharper focus. The group in dispute remains catalogued under his name, but it is clear that Berenson had never ceased to wrestle with the problem and was far from regarding it as settled. Though D'Achiardi in 1908 had claimed his support for the re-attribution of the Louvre *Dead Christ*, and in spite of Panofsky's arguments, it is significant that he retains this drawing under the name of Michelangelo; and he puts his finger on the essential flaw in the whole argument when he observes that "it remains disconcerting that the few drawings by Sebastiano which have never been disputed betray no unusual intimacy with Michelangelo's style." Though his intellectual honesty made it impossible for him to gloss over the weaknesses in the theory, he could not bring himself to take the final step of abandoning it altogether; but the argument to which he was eventually reduced —that the chalk scribbles on the back of the panel of the Viterbo *Pietà* (BB 2503A)

must be by Sebastiano and are stylistically inseparable from the "Michelangelesque" group of drawings—seems an unconvincing piece of special pleading. The first attempt to define Sebastiano's independent drawing style was made soon afterwards by Oskar Fischel (*Old Master Drawings*, xiv [1939/40], pp. 21ff.), who concluded that the Wickhoff-Berenson Sebastiano was a split personality: ". . . two distinct groups of drawings, both bearing Sebastiano's name, confront each other. Surveying them at a glance, it would almost seem as if, like Rodin in his early days at Antwerp, he had kept two different studios; or, should we say, as if he had had two different minds, one for his everyday work on which he bestowed a rather phlegmatic and earth-bound nature, and one for his profounder and more creative ideas, which placed him alongside no less a man than Michelangelo? On drawings of the former class the amateurs of bygone days inscribed, quite logically, the name Fra Sebastian del Piombo; those of the other class it seems to have been the privilege of modern scholarship to discover. Can it be that both are right?"

The note of warning sounded by Fischel was ignored in the monographs on Sebastiano by Luitpold Dussler (1942) and Rodolfo Pallucchini (1944), both of whom accepted Sebastiano's authorship of all six drawings as a matter of indisputable fact. The first critic to reaffirm in so many words the traditional attribution to Michelangelo was Johannes Wilde in his catalogue of the Michelangelo drawings in the British Museum (1950). But even he excluded the *Christ at the Column*, the re-attribution of which was first proposed, with his full agreement, in the catalogue of drawings by Raphael and his Circle (1962).

Subsequent opinion is still divided. The case for Sebastiano was stated at length by Sydney Freedberg (*Art Bulletin*, xlv [1963], pp. 253ff.), but he later emphasized (*Painting in Italy, 1500–1600*, 1970, p. 473, note 74) that the question cannot be regarded as settled and that the purpose of his earlier article had been merely to provide a basis for discussion. Dussler classified five of the six drawings (the exception being the *Christ at the Column*) in the apocryphal section of his Michelangelo corpus (1959), and continued to maintain the attribution to Sebastiano. Hartt in his corpus (1971) likewise omitted from the Michelangelo canon all three of the Lazarus studies and the *Flagellation* composition-sketch. He considered that the *Christ at the Column* was originally a study for the torso of the "Rebellious Slave," which Sebastiano transformed into the figure of Christ by the addition of the head and the "tremulous contours"; and that, similarly, the torso and upper arms of the Louvre *Dead Christ* are by Michelangelo, and the rest by Sebastiano. Charles de Tolnay accepted the Sebastiano attribution in his monograph on Michelangelo (1943–60) but in his corpus of Michelangelo's drawings he follows Wilde in reverting to the traditional attribution for all three

Lazarus studies, the *Flagellation* composition-sketch, and the Louvre *Dead Christ*. Like Hartt, he considers the study of *Christ at the Column* a composite production, sketched in by Michelangelo and elaborated and completed by Sebastiano.

After this lengthy, and ultimately inconclusive, analysis of the fluctuations of critical opinion, it is time to turn to the drawings themselves. Any conclusions about their authorship depends finally on the internal evidence of style; but the external testimony of Vasari must also be taken into account. Though Vasari was a conscientious historian, his reliability is obviously greater the nearer he is to the events described: that he should repeat the current legends about Giotto and Cimabue in no way diminishes his credibility when relating events directly within his own experience or that of his informant. He was well acquainted with Michelangelo, who would have given him a firsthand account of his collaboration with Sebastiano, and the first point that immediately strikes us is the scrupulous care with which he distinguishes the extent of Michelangelo's participation in Sebastiano's three commissions of *c.* 1515–16. In the *Pietà*, Sebastiano was responsible for the much-admired landscape background and Michelangelo for the "cartone," i.e., the figural group; for the *Flagellation* Michelangelo was expected to, and did, provide the design of the entire composition; in the *Raising of Lazarus* his assistance was limited to part of the composition. A contemporary chronicler who goes to such trouble to draw these fine distinctions surely deserves to be taken seriously, but it is interesting to see the perverse ingenuity with which the proponents—or, one is tempted to say, the prisoners—of the Sebastiano theory have sought to play down the value of Vasari's evidence. Wickhoff, for example, refers to Sebastiano's unsuccessful bid, after Raphael's death in 1520, to get the commission for the Sala di Costantino by securing the promise of Michelangelo's collaboration, and suggested that Vasari's statements were based on nothing more substantial than a confused hearsay account of this episode; while Berenson, adopting a tone of bluff common sense, pleaded "the inherent probability that the author of the painting was the author also of a sketch in many ways so essentially identical with it." Others again have suggested that Michelangelo did supply Sebastiano with drawings but that these were studies made for some other purpose which the recipient was left to adapt as best he could, and much ingenuity has been devoted to tracing similarities of motif. It is true that a letter survives in which Sebastiano begs Michelangelo to remember to send him, what he has so long wanted, any studies of figures or legs or bodies or arms that can be spared ("pregovi a recordative di portarmi qualche cossa figure o ganbe o corpi o brace che tanto tempo le ho dessiderato"), but this was written in 1532; the Louvre *Dead Christ* may indeed have been made by Michelangelo for some purpose of his

own and later sent to Sebastiano in response to such an appeal, but Vasari makes it clear that in about 1515 Michelangelo recognized Sebastiano as a potential ally in his rivalry with Raphael and set out to give him as much encouragement and practical assistance as were within his power, and that this assistance extended to giving advice on the design of the paintings themselves. It is difficult to see how this advice can have been given if not in the form of drawings.

The probability that Vasari's account is substantially correct is not in itself enough to establish Michelangelo's responsibility for studies for the *Flagellation* or the *Raising of Lazarus*. The ultimate criteria must be those of artistic personality and style, and the interpretation of these must ultimately be a matter of subjective opinion. But the argument hinted at by Berenson and elaborated by Fischel is surely a valid one: the group of drawings certainly attributable to the independent Sebastiano is consistent within itself and expressive of a personality wholly unlike that revealed by the Michelangelesque drawings with which modern criticism has enriched his oeuvre. If this second group is also by Sebastiano we should have to assume that at the age of about thirty, when his style was already formed, he became capable of totally subordinating his personality to that of another artist. Such sudden adaptability at so relatively mature an age is surely improbable. Furthermore, his capacity for subordination, though total, was strangely intermittent. The study in Frankfurt for the figure of Martha directly behind the group of Lazarus and his supporters in the National Gallery altarpiece is in Sebastiano's characteristic independent style. If the studies for the group with Lazarus are also by him, it would be necessary to make the further and even more improbable assumption that he was capable of switching from one style to the other while at work on the same picture. The same contrast—surely inexplicable except on the assumption that two different hands were responsible—can be observed between the Michelangelesque studies for the *Flagellation* and those in Sebastiano's independent style for the reclining Apostle in the semidome immediately above (Chatsworth) and for the Prophets in the spandrels (Kremsier and private collection, Washington). Berenson, with his usual intellectual honesty, admits that this is not easy to account for; and his suggested explanation "that the strain [of emulating Michelangelo] was so great upon Sebastiano that in the midst even of his utmost effort he had occasionally to relax and fall back on his more usual self" is not put forward with any great appearance of conviction.

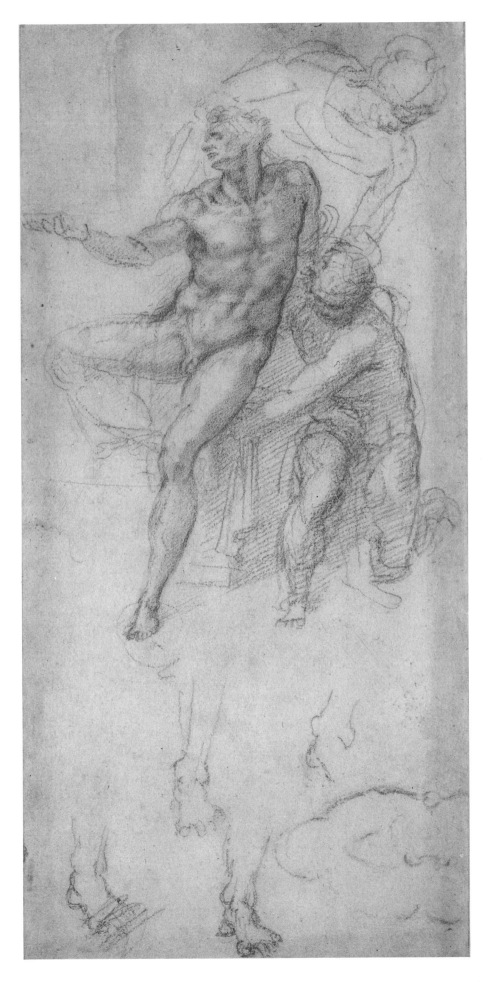

Number 9, see overleaf

9 LAZARUS RAISED FROM THE DEAD, SUPPORTED BY TWO FIGURES; STUDIES OF A LEFT FOOT

Red chalk.

252: 119 mm. Trimmed on the left and right. A rectangular piece of the top on the left made up.

1860–7–14–2

PROVENANCE: Casa Buonarroti; J. B. J. Wicar; Sir T. Lawrence; William II of Holland; S. Woodburn (sale, Christie's, 1860, 4 June, lot 112, bt, *Farrer, £33–12–0*).

LITERATURE: Lawrence Gallery 83; F. Wickhoff, *Jahrbuch der Königlich Preussischen Kunstsammlungen*, xx (1899), p. 206; BB 2483; Thode 330; P. d'Achiardi, *Sebastiano del Piombo*, Rome, 1908, pp. 304, 319f. (N.B., d'Achiardi in his descriptions confuses Wilde 16 and 17); Brinckmann 93; L. Dussler, *Sebastiano del Piombo*, Basle, 1942, pp. 89ff., 170f.; R. Pallucchini, *Sebastian Viniziano*, Milan, 1944, pp. 49f., 80f., 177; Tolnay 1948, p. 20; Wilde 16; Dussler 562; S. J. Freedberg, *Art Bulletin*, xlv (1963), p. 256; BM exh. 1975, no. 40; Tolnay [i] 76.

See no. 8.

10 STUDY FOR A DOUBLE TOMB; FIGURE FOR A SARCOPHAGUS recto. STUDIES FOR A DOUBLE AND A SINGLE TOMB verso.

Black chalk.

264: 188 mm.

1859–5–14–822

PROVENANCE: Casa Buonarroti.

LITERATURE: Symonds, i, pp. 383f.; BB 1495; Geymüller, pp. 18f.; Burger, pp. 354f.; Frey 47, 48; Thode 318; Popp, *Medici-Kapelle*, pp. 21ff., 126ff.; Brinckmann 35; V. Fasolo, *Architettura e arti decorative*, vi (1927), p. 396; Tolnay 1928, pp. 383f., 388; the same, *L'Arte*, N.S., v (1934), pp. 11f., 15; E. Panofsky, *Studies in Iconology*, New York, 1939, pp. 199f.; Tolnay 1948, pp. 34ff., 42f., 45, 47, 83, 127ff., 134, 148, 150, 169, 203f. (nos. 51, 52); H.-W. Frey, *Zeitschrift für Kunstgeschichte*, xiv (1951), p. 56; Tolnay 1951, p. 56; Wilde 26; Dussler 150; J. Ackerman, *The Architecture of Michelangelo*, London, 1961, pp. 26f.; Hartt 217, 218; BM exh. 1975, no. 49; Tolnay [ii] 180.

DURING the years which Michelangelo spent in Florence, from 1516 to 1532, much of his time was taken up with commissions from the two Medici Popes, Leo X (1513–21) and Clement VII (1523–34), formerly Cardinal Giulio de' Medici, for the embellishment of the family church of S. Lorenzo. In 1516 Leo ordered him to complete the façade, but the commission came to nothing and was cancelled in 1520 in favor of Cardinal Giulio's proposal to attach a funerary chapel ("The New Sacristy") to the right transept of the church which would be the counterpart to Brunelleschi's Old Sacristy on the opposite side, a proposal prompted by the deaths, in 1516 and 1519 respectively, of the Pope's brother, Giuliano de' Medici, Duke of Nemours, and his nephew Lorenzo de' Medici, Duke of Urbino. The original intention was that these (the "Capitani") should be commemorated in the chapel together with the two "Magnifici," the Pope's father, Lorenzo the Magnificent, and the latter's brother Giuliano, the father of Cardinal Giulio.

The British Museum is fortunate in possessing a sequence of drawings which illustrate what can be learnt from documentary sources about the successive phases of Michelangelo's plan for the placing of the four tombs. At first he suggested putting the four sarcophagi each on one face of a free-standing quadrilateral structure, but this solution was ruled out because, given the size of the chapel, any such structure would have to have been unduly small if there were to be enough space for it to be seen properly. He then proposed to put the tombs against the side walls, either in pairs in the center or singly at either extremity of the wall. His final solution, which was only partially carried out, was to place the single tombs of the *Capitani* in niches in the

57

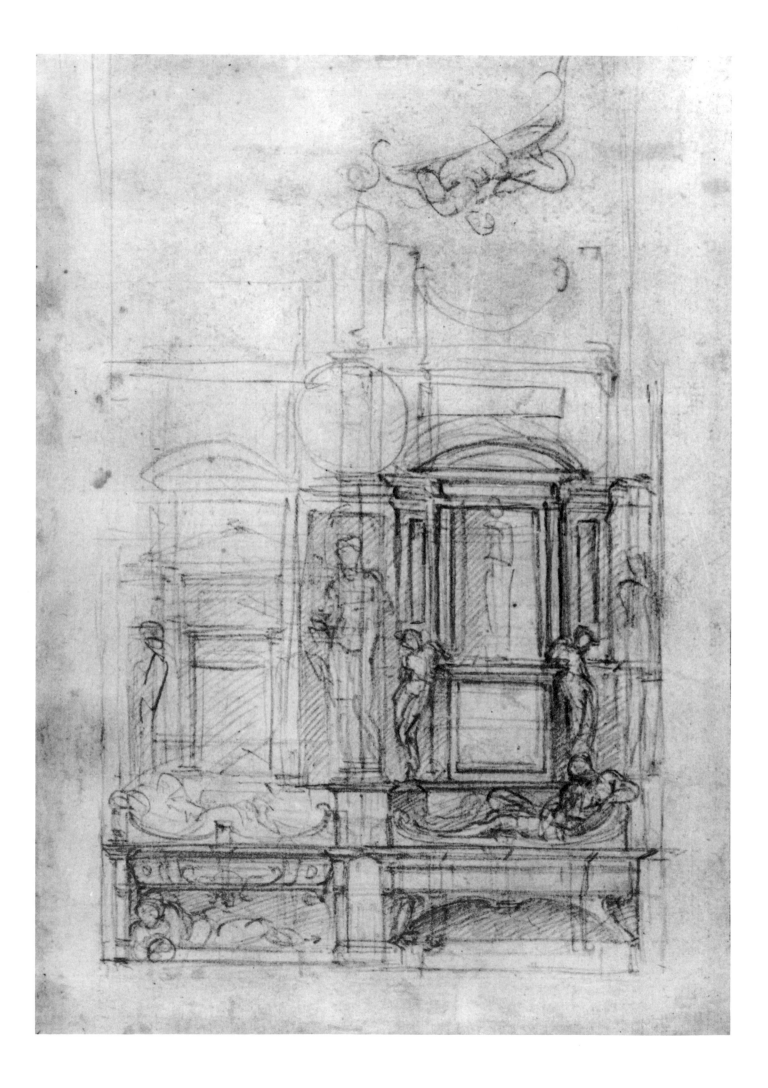

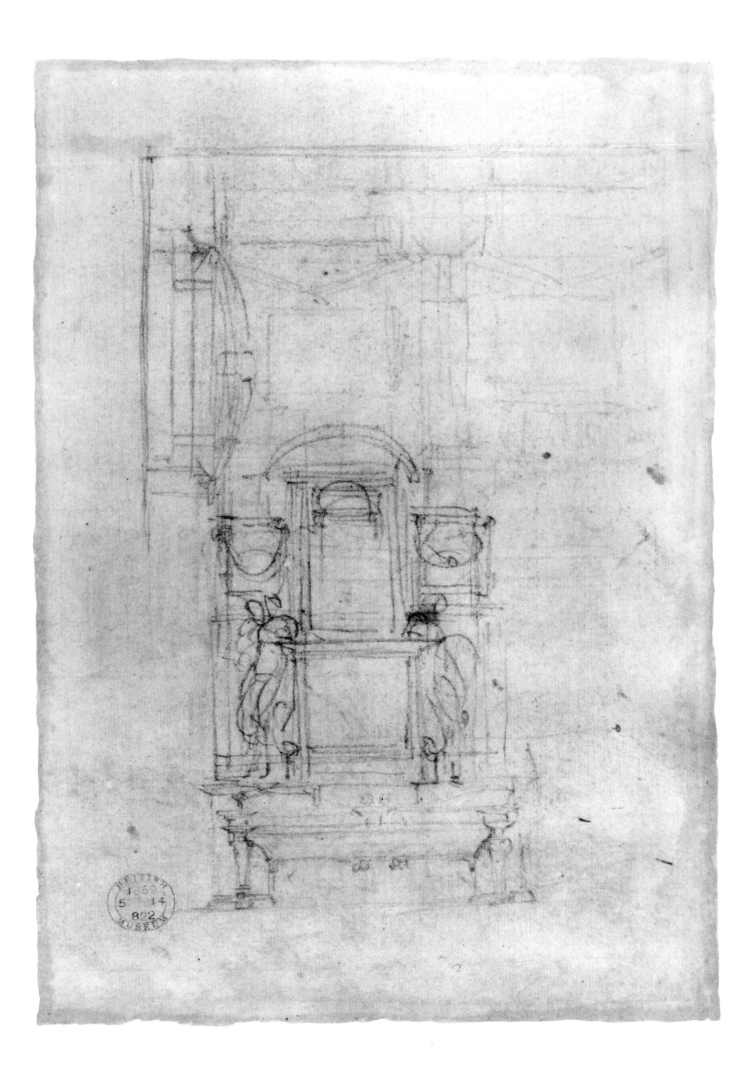

center of each side wall and the double tomb of the *Magnifici* on the end wall, facing the altar which is in a niche in the opposite wall with its back turned towards the chapel; thus the tomb of the *Magnifici*, though separated from the altar by the whole extent of the chapel, would in effect have been the reredos on the altar wall and as such was to have embodied a group of the Virgin and Child and statues of the patron saints of the Medici family, Cosmas and Damian.

No. 10 recto and the slighter sketch on the verso (made with the sheet inverted) are for a double tomb, evidently connected with the proposal to place the four tombs in pairs opposite one another in the center of the side walls. The more highly realized study on the verso, drawn over the slighter sketch of the double tomb, has been variously interpreted. Though it is clearly a variant of one-half of the double wall-tomb on the recto, Dussler and Tolnay see it as an elevation of one face of a free-standing structure. Wilde on the other hand sees it as a wall-tomb. He observes that it is narrower in proportion than the single tombs eventually placed in the center of the side walls, and connects it with the proposal to place the four tombs singly at either end of each wall. (Hartt's suggestion that it is for a double tomb with a single sarcophagus seems to us far-fetched.) On the whole we consider Wilde's interpretation more likely: the sides of the tomb are emphatically vertical, as they would be if it were intended to fill a rectangular space; the outline of a free-standing structure would surely have been more *mouvementé*; there is no indication of the profiles of the sarcophagi that would have protruded on either side; and the designs that are certainly for the free-standing solution show a structure much wider in proportion to its height.

11

STUDY FOR A DOUBLE TOMB; HANDWRITING recto.

STUDY FOR A DOUBLE TOMB verso.

Pen and dark brown ink. The drawing of the recto shows through on the verso.

210: 162 mm. Trimmed along the top edge, and the top right corner made up.

1859–6–25–543

PROVENANCE: B. Buontalenti (cf. no. 2); Casa Buonarroti.

LITERATURE: BB 1496; Geymüller, pp. 18f.; Burger, p. 357; Frey 9a, 9b; Thode 285; Popp, *Medici-Kapelle*, pp. 33ff., 130, 132, 163; E. Panofsky, *Jahrbuch für Kunstgeschichte*, i (1921–2), Buchbesprechungen, col. 45; V. Fasolo, *Architettura e arti decorative*, vi (1927), p. 450; Tolnay 1928, p. 389; E. Panofsky, *Studies in Iconology*, New York, 1939, p. 187, note 51; Tolnay 1948, pp. 39f., 70f., 73, 96, 127, 130, 146, 164, 169, 205 (nos. 58, 59); H.-W. Frey, *Zeitschrift für Kunstgeschichte*, xiv (1951), pp. 65f., 70; Wilde 28; Dussler 153; J. Ackerman, *The Architecture of Michelangelo*, London, 1961, pp. 26f.; Hartt 224, 223; BM exh. 1975, no. 51; Tolnay [ii] 189.

INSCRIBED along the bottom of the recto in Michelangelo's hand and in the same ink as the drawing: *la fama tiene gli epitafi a giacere no[n] va ne ina[n]zi ne indietro / p[er]ch[e] so[n] morti e e loro op[er]are e fermo* ("Fame holds the epitaphs in position; it goes neither forward nor backward for they are dead and their work is finished").

A rough sketch for the double tomb of the *Magnifici* as it was to have been executed in Michelangelo's eventual scheme (see no. 8), it differs from what may be presumed to be the final design (known from studio copies in Oxford, the Louvre, and elsewhere: see BM 1975 exh., p. 57, and Tolnay, [ii], 194 and p. 35), in which the *basamento* of the main storey is omitted, the central tabernacle is lower and separated from the cornice by an oblong tablet, and the spaces between the pairs of pilasters contain two figures one above the other; the side roundels are omitted and replaced by a larger single roundel attached to the center of the cornice; and there are reclining figures on the sarcophagi.

Panofsky's identification of the crouching figure with extended arms, very summarily indicated in the center section of the *basamento*, as *Fame* is borne out by the inscription.

The even rougher sketch on the verso is a variant of the recto design, the principal difference being that there are seated figures on either side of the *basamento* immediately above the sarcophagi. We agree with Tolnay that these were probably intended to be effigies of the *Magnifici*, and that Cosmas and Damian would have been placed above, on the same level as the figure of the Virgin.

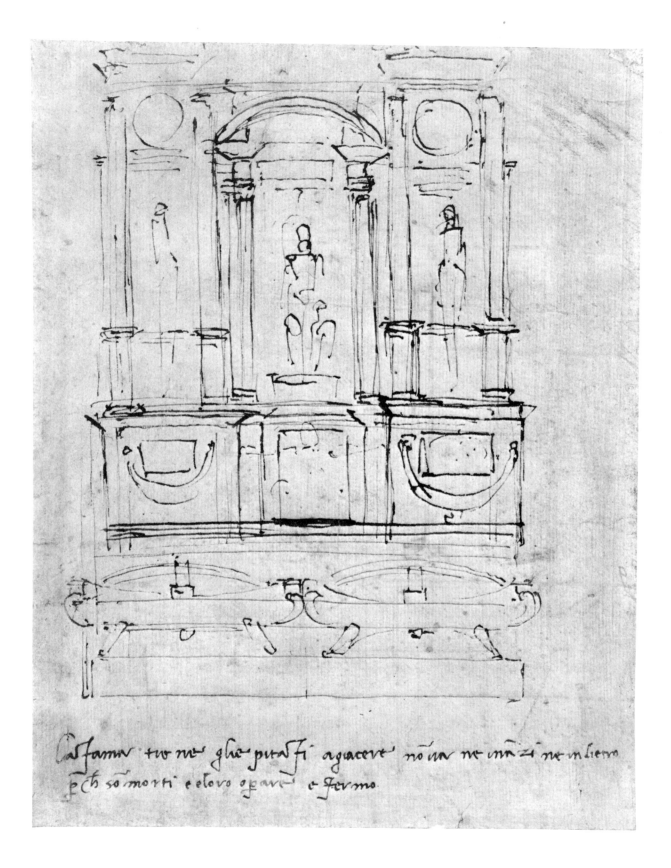

Chalfama tuo me ghe pietassi agiacere no ua ne inazi ne indietro
pch so morti e eloro opare e fermo.

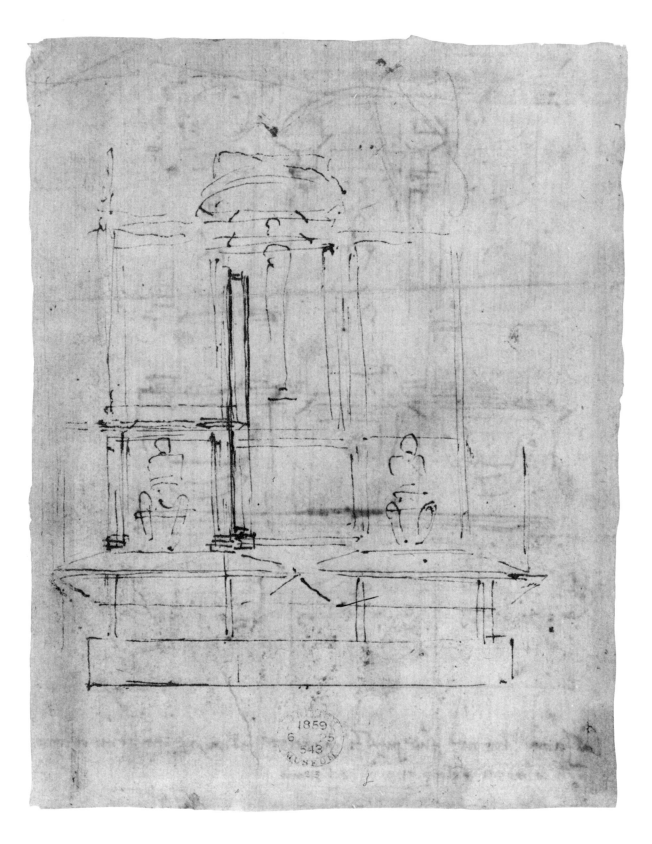

12 FOUR GROTESQUE HEADS; HERCULES AND ANTAEUS recto. A SHIELD; HEAD OF A YOUTH; TWO MEN WITH SPEARS verso.

RECTO: red chalk, the sketch of *Hercules and Antaeus* first drawn in lightly in black chalk. All the drawings have been outlined with a sharp instrument, probably through tracing by a copyist. VERSO: black chalk; red chalk, gone over with a sharp stylus (the sketch of two men with spears).

255: 350 mm. WM: JCR *Oxford*, no. 10. An oblique crease top right.

1859-6-25-557

PROVENANCE: Casa Buonarroti.

LITERATURE: JCR *Oxford*, p. 57, note; BB 1490; Steinmann 79; Frey 31, 32; Thode 299; Popp, *Medici-Kapelle*, pp. 156f.; the same, *Belvedere*, viii (1925), p. 17; Brinckmann 43; J. Wilde, *Jahrbuch des Kunsthistorischen Sammlungen in Wien*, N.S., ii (1928), pp. 203f.; R. Wittkower, *Journal of the Warburg Institute*, i (1937–8), pp. 183ff.; E. Panofsky, *Studies in Iconology*, New York, 1939, p. 232; Tolnay 1948, pp. 87, 101f., 184, 214 (no. 91); Wilde 33; Dussler 159; Hartt 496, 186; BM exh. 1975, no. 91; Tolnay [ii] 236.

TWO sketches of a group of Hercules and Antaeus similar to the one in the lower right corner of the recto are on a sheet in Oxford (BB 1712; Hartt 302), and a highly finished drawing of the same subject occurs on the "presentation sheet" at Windsor of the *Three Exploits of Hercules* (Popham-Wilde 423; Hartt 360) which is datable *c.* 1530. The style of the sketches (and of the others on the present sheet) suggests a somewhat earlier dating, *c.* 1524; they have generally been connected with the final stage of Michelangelo's project for the colossal marble group which was to have stood outside the Palazzo della Signoria in Florence as a companion to the marble *David*, completed in 1504. David and Hercules were regarded as symbolic of the virtues of the short-lived Florentine republic (1494–1512), of which Michelangelo was an ardent supporter; it was no doubt partly for this reason that when the Medici returned to power the commission was offered in 1524 to his ambitious rival Baccio Bandinelli, in spite of Michelangelo's offer to carve the group for nothing. The sketches of Hercules and Antaeus presumably date from this second phase of the commission.

Critics have suggested a connection between the grotesque faces on the recto and the masks which occur as decorative motifs in the Medici Chapel (cf., e.g., those reproduced by Tolnay 1948, figs. 196–99, and 330): it is true that the drawings are more caricatural and less formalized, but something of the kind may have served as Michelangelo's point of departure.

The drawing on the verso is a palimpsest. The black chalk studies were drawn first. They consist of an oval cartouche surmounted by two wing-shaped finials which

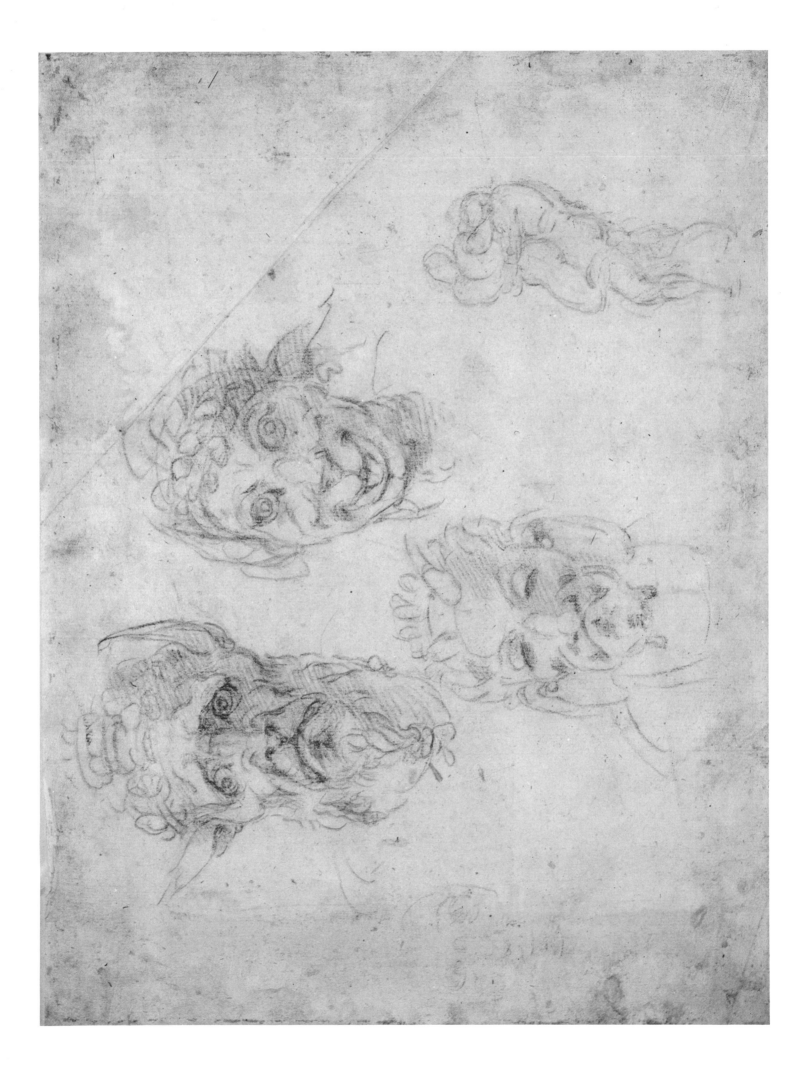

seem to have been conceived in relation to a triangular pediment immediately above. Below the cartouche and drawn with the sheet turned sideways is a grotesque face with pouting lips, wearing askew on the side of the head a mask attached by a band running across the face below the right eye. Drawn over this in red chalk are two nude men looking upwards and holding long spears which converge at a point just above the apex of the pediment. The purpose of these sketches has never been satisfactorily explained, though some critics have connected the red chalk figures with the *Brazen Serpent* drawing at Oxford (Parker 318; Hartt 257). Hartt claims to see the Medici *palle* in the cartouche, but the forms that he so interprets are part of the red chalk drawing.

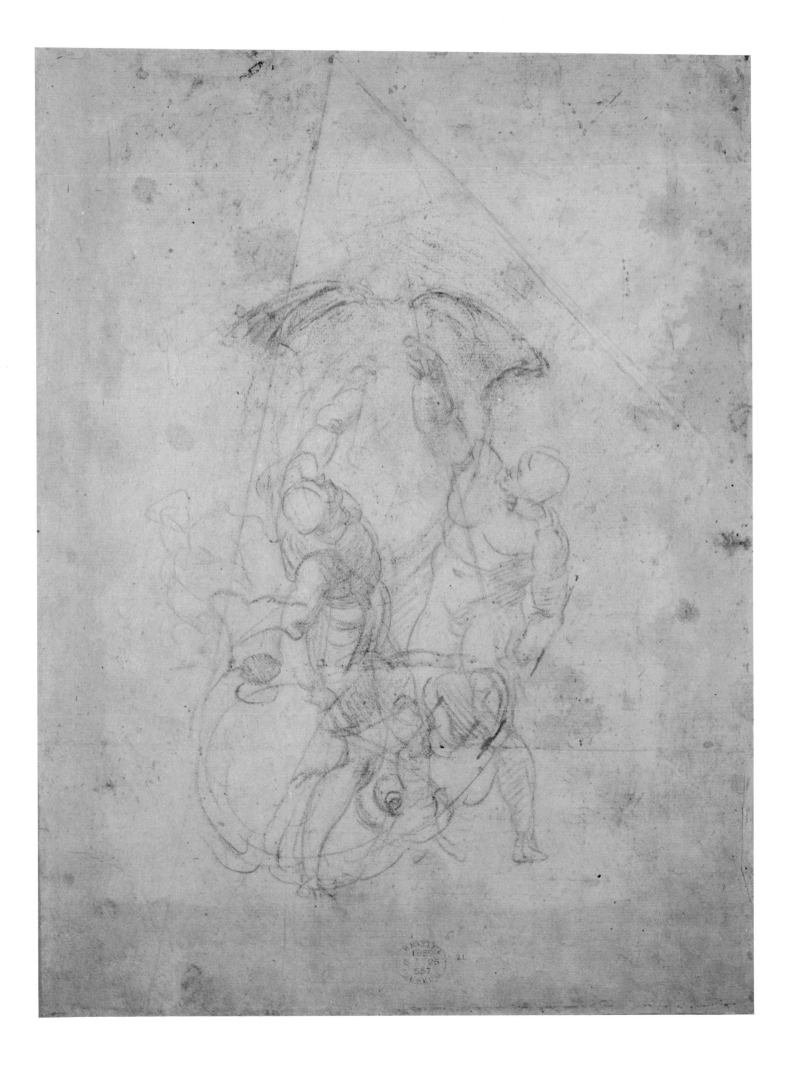

13

STUDIES FOR A MONUMENTAL WALL-TOMB recto.
HEAD OF A YOUTH IN PROFILE verso.

RECTO: pen and brown ink. VERSO: black chalk, rather rubbed.

175: 182 mm. WM: JCR *Oxford*, no. 33. Cut at the top and on the right.

1895-9-15-507

PROVENANCE: Sir T. Lawrence (according to Robinson); J. C. Robinson; J. Malcolm of Poltalloch; purchased with the Malcolm Collection in 1895.

LITERATURE: JCR 70; BB 1527; Frey 120a, 120b; J. Baum, *Monatshefte für Kunstwissenschaft*, i, (1908), pp. 1115ff.; Thode 354; V. Fasolo, *Architettura e arti decorative*, vi (1927), p. 445; A. E. Popp, *Münchner Jahrbuch*, N.S., iv (1927), p. 405, note 9; Wilde 39; Dussler 330, 574; J. Ackerman, *The Architecture of Michelangelo*, London, 1961, p. 29; Hartt 318; BM exh. 1975, no. 55; Tolnay [ii] 192, 193.

SEVERAL critics, including Berenson, Frey, and Thode, have connected these sketches with the entrance vestibule (the 'ricetto') of the library attached to the church of S. Lorenzo in Florence, on which Michelangelo was working from 1524 onwards. In its complex spatial organization involving recessed columns, etc., the architecture in these sketches resembles that of the *ricetto*, but the indication of a sarcophagus in front of the *basamento* of the principal elevation on the sheet shows that these must be studies for a tomb. Tolnay connects the lower drawing with the *ricetto* and the upper one with the tomb of the *Magnifici* proposed for the New Sacristy in S. Lorenzo (see no. 10), but all the sketches on the recto were surely drawn at the same time and must relate to the same project. Evidently also for this project are two drawings in the Casa Buonarroti (46A and 128A; Hartt 319 and 320), likewise for a single wall-tomb, and a sheet of studies for a double tomb in the Ashmolean Museum, Oxford (Parker 308; Hartt 222). A more convincing explanation was suggested by A. E. Popp apropos of the two drawings in the Casa Buonarroti (she rejected the others), that they are connected with the abortive proposal to place in S. Lorenzo the tombs of the two Medici popes, Leo X and Clement VII, which was put forward by Clement soon after his election in November 1523 and is referred to more than once in letters to Michelangelo during the next three years.

It proved to be impossible to place the tombs in the New Sacristy itself because work there was already too far advanced, and Michelangelo suggested that they should go in the two small side rooms of the Sacristy. When Clement rejected this position as being insufficiently conspicuous, Michelangelo was asked to suggest a better one in the church itself. The choir would have been the most likely place, in which single tombs

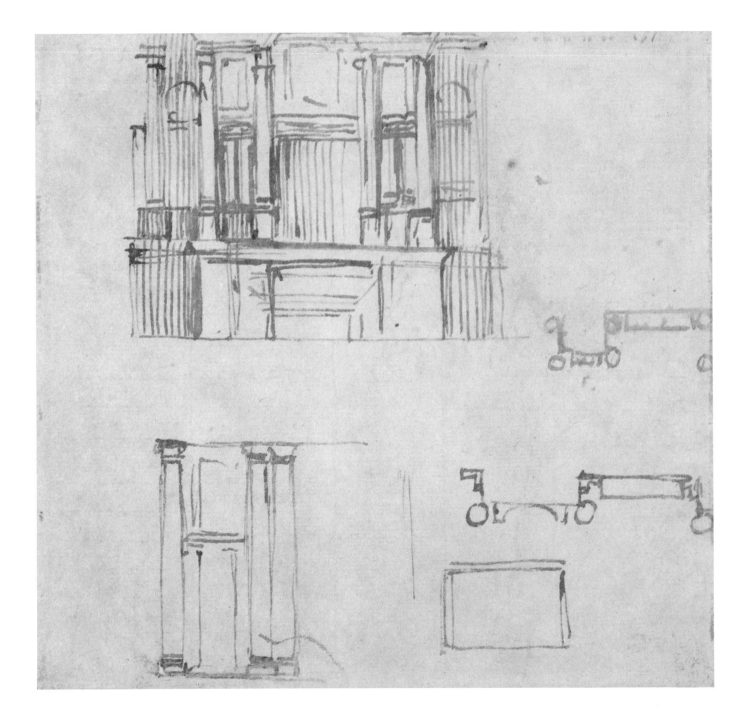

would either have faced one another (probably, as Wilde suggested, at the far end beyond the high altar) or there would have been a double tomb (for which the Oxford drawing is presumably a design) on the end wall.

The slight black chalk profile on the verso has been generally dismissed, but it seems to us that the quality of the drawing (so far as it goes) is worthy of Michelangelo himself. Michael Hirst has pointed out that similar heads occur in the *Last Judgment* (cf., for example, that of the heavily draped woman standing in the center of the left-hand lower section).

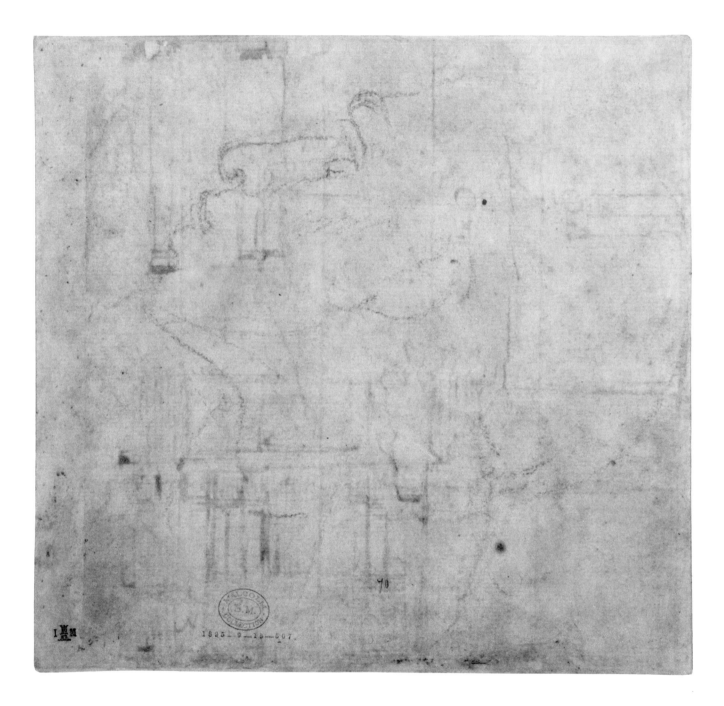

14 FEMALE HALF-LENGTH FIGURE recto.
FEMALE HALF-LENGTH FIGURE verso.

RECTO: first drawn in lightly in red chalk (at the top) and black chalk at the bottom, then finished in pen and brown ink; the modelling of the face is entirely in red chalk. VERSO: lightly drawn in black chalk and only partly shaded. To left of the head are some black chalk scribbles by another hand.

323: 258 mm. Made up along the top and in the right bottom corner.

1859–6–25–547

PROVENANCE: Casa Buonarroti.

LITERATURE: H. Wölfflin, *Jugendwerke des Michelangelo*, Munich, 1891, pp. 58ff.; BB 1482; Frey 184, 185; Thode 289; Brinckmann 29; A. E. Popp, *Belvedere*, viii (1925), pp. 14, 16, and Forum, pp. 74f.; Tolnay 1930, p. 520; Berenson, *L'Arte*, N.S., vi (1935), p. 261; Tolnay 1948, pp. 213ff. (no. 90); Wilde 41; Dussler 307; Hartt 366, 367; BM exh. 1975, no. 113; Tolnay [ii] 320.

THE purpose of these drawings is unknown. Wilde sees them as examples of the "teste divine" which according to Vasari Michelangelo made as presents for his friends. It is clear that Michelangelo took exceptional pains with his "presentation drawings" (cf., e.g., nos. 15 and 16), which he brought to a very high degree of finish and which were regarded as independent works of art in their own right. The two drawings on the present sheet are surely too sketchy to have been themselves intended for this purpose; but the feeling of psychological isolation about both figures, and their elaborately fanciful costume, makes it not unlikely that they were preliminary studies for a presentation drawing.

The significance (if any) is far from clear of the small-scale stooping figure apparently standing on the lap of the recto woman. Wilde considered that the smaller figure was drawn first and that there was no connection between the two. Tolnay, on the other hand, sees the woman as the Virgin carrying on her lap a diminutive St. Christopher on whose back is seated the Christ Child contained within a circular glory. It is true that the head and right arm of the "Child" could equally well be interpreted as the first two fingers of the woman's hand, which seems to be holding something between forefinger and thumb; but it is more difficult to explain the left leg as part of the hand, especially since it seems to have been drawn in relation to the "St. Christopher."

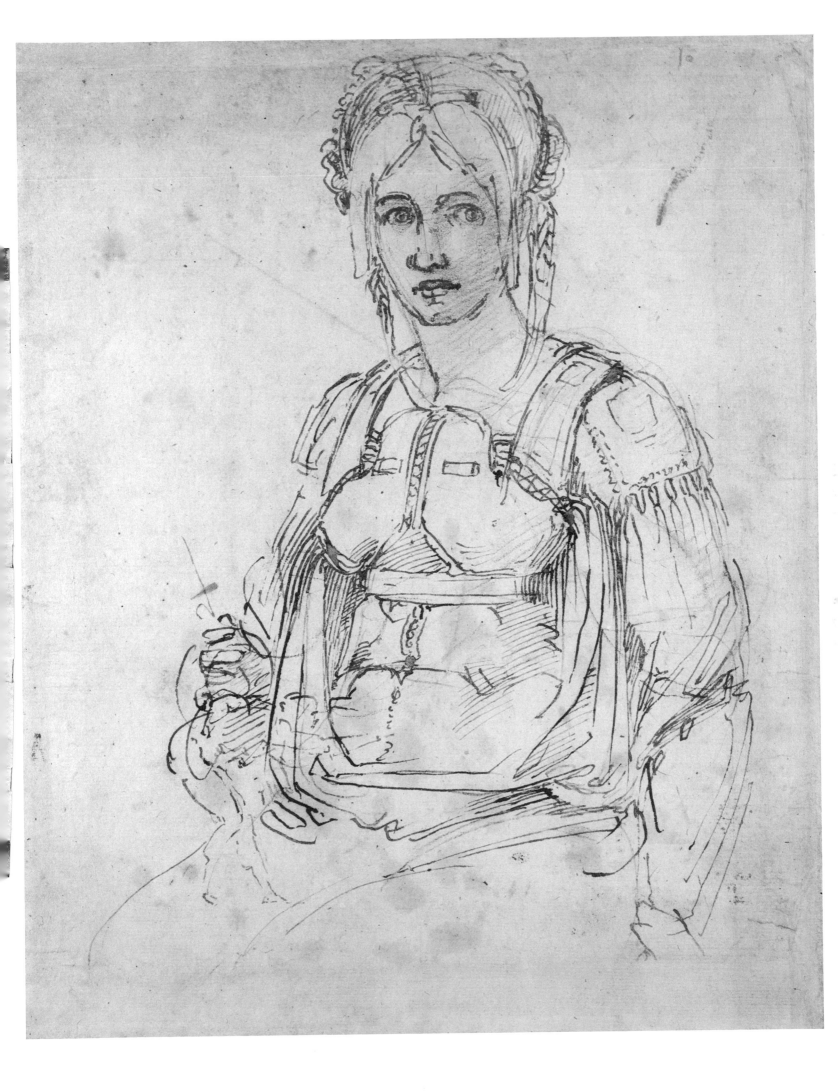

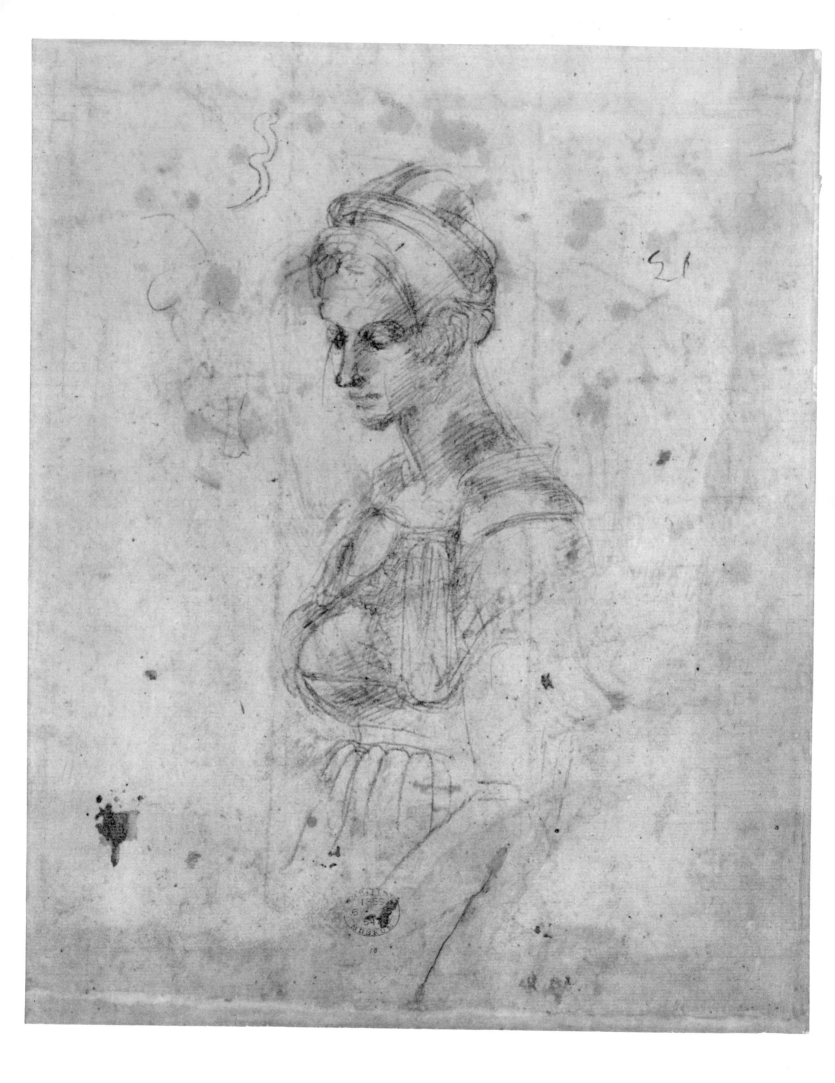

15 IDEAL HEAD OF A WOMAN recto.
STUDIES OF HEADS AND FIGURES verso.

RECTO: black chalk. VERSO: red chalk.

287: 235 mm. WM: JCR *Oxford*, no. 33. Trimmed on all sides; a large area made up in the bottom left corner.

1895–9–15–493

PROVENANCE: Casa Buonarroti and J. B. J. Wicar (according to Lawrence Gallery); W. Y. Ottley (according to JCR); Sir T. Lawrence; Rev. Dr. H. Wellesley (sale, Sotheby, 1866, 10 July, lot 2417, bt, *Addington*, £290); J. Addington (from whom purchased by Malcolm, 15 February 1867); J. Malcolm of Poltalloch; purchased with the Malcolm Collection, 1895.

LITERATURE: Lawrence Gallery 15 (pl. 17); JCR 56; Loeser 1897, p. 352; BB 1689; Frey 289, 290; Thode 344; A. E. Popp, *Belvedere*, viii (1925), p. 20 (no. 14); Berenson, *L'Arte*, N.S., vi (1935), pp. 243, 251, 262; Wilde 42; Dussler 568; Hartt 365, 313; BM exh. 1975, no. 114; Tolnay [ii] 316.

MICHELANGELO was in the habit of occasionally making highly finished drawings in black or red chalk as gifts for his particular friends. These "presentation drawings" (to use the term coined by Wilde) were intended as works of art complete in themselves. The three "teste a matita nera divine" which Vasari (vii, p. 276) says Michelangelo gave to a Florentine nobleman named Gherardo Perini were no doubt of the same type as this meticulously executed black chalk drawing of an ideal female head with elaborately braided hair and wearing a fantastic cap. Such idealized and ornately decorated profile heads were to inspire the younger generation of Florentine Mannerists such as Vasari and Francesco Salviati.

The head bore the traditional title of *Marchesa di Pescara* (i.e., Vittoria Colonna: see no. 21). A similar drawing in black chalk of the head of a bearded man wearing a fantastic helmet, also in the British Museum, was traditionally known as *The Count of Canossa*. The two have generally been regarded as a pair, and their high degree of finish and the obviously inferior quality of the male head led critics to reject Michelangelo's authorship of both. Thode was the first to observe that they are by different hands, the female head being by Michelangelo himself and the other no more than an old copy of a lost drawing. In this opinion he was followed by Wilde, Hartt, and Tolnay. Dussler rejects both drawings.

Wilde suggests a date *c.* 1525–8—somewhat earlier than the presentation drawings made for Tommaso de' Cavalieri—for this drawing and the lost original of the male head. He considers that they were probably intended as a pair, perhaps representing Venus and Mars. But the two are not so alike as necessarily to have been conceived

together. The identification of the female head as that of Vittoria Colonna is clearly a romantic invention, but equally there is nothing about it particularly suggestive of Venus; and there is reason to suppose that Michelangelo intended the other as a fancy portrait of an early Count of Canossa from whom he believed himself descended (see BM exh. 1975, no. 115).

Of the drawings on the verso, the grotesque head in profile, the squatting boy, and the head and shoulders of the man in a plumed hat are by Michelangelo. The other childish scribbles, including an attempt to copy the head of the youth, are evidently by a pupil or pupils.

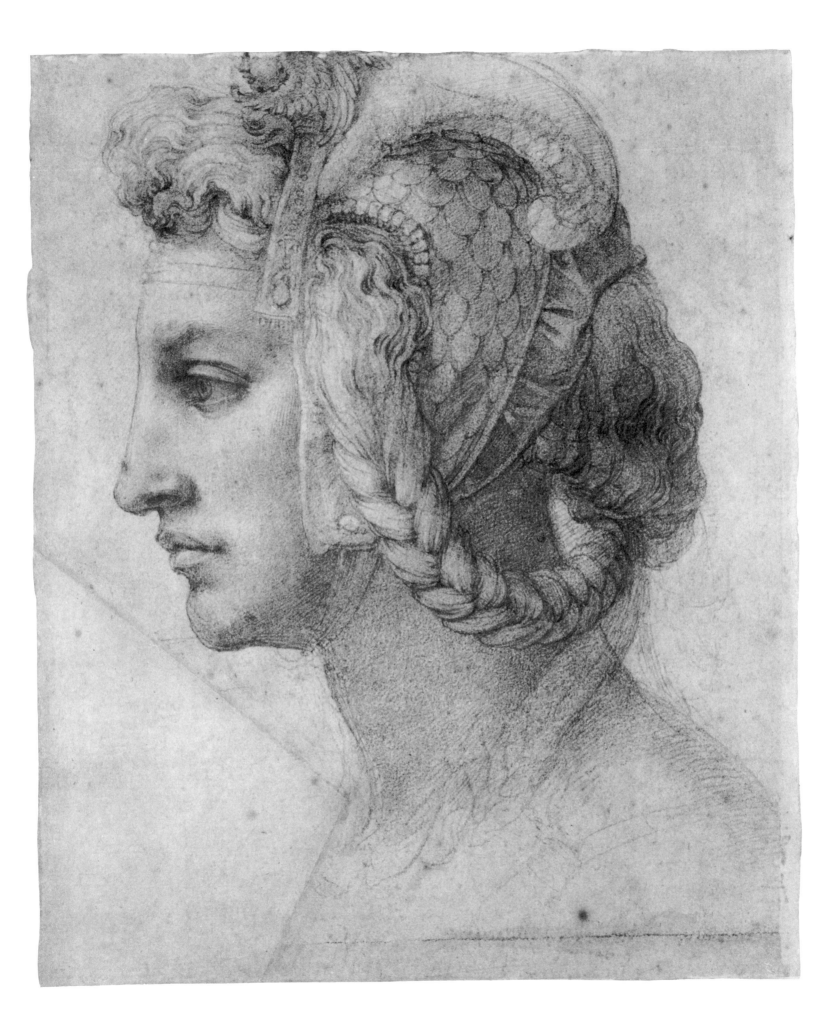

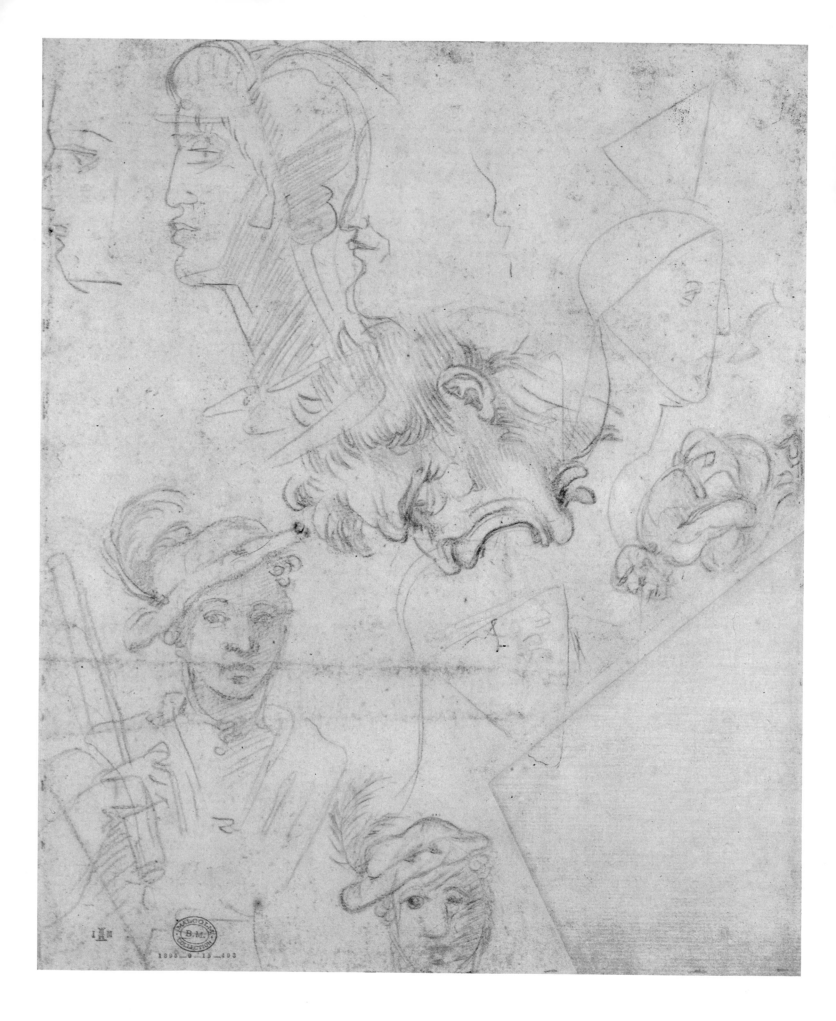

16 THE FALL OF PHAETHON

Black chalk.

313: 217 mm. Slightly trimmed on the left. Traces of framing-lines in ink on all four sides.

1895-9-15-517

PROVENANCE: Moselli, Verona (cf. Vasari's *Vita di Michelagnolo*, ed. Bottari, Rome, 1760, p. 125, note 3); P. Crozat; P.-J. Mariette (L. 2097); marquis de Lagoy (L. 1710); T. Dimsdale (L. 2426); Sir T. Lawrence (L. 2445); S. Woodburn (sale, Christie's, 1860, 4 June, lot 138, bt, *Clément*, £45-3-0); E. Galichon (sale, Paris, Clément, 1875, 10 May, lot 15); J. Malcolm of Poltalloch (bought for £220 at the Galichon sale); purchased with the Malcolm Collection in 1895.

LITERATURE: P.-J. Mariette, *Description . . . du Cabinet du feu M. Crozat*, Paris, 1741, p. 3*, no. 10, and in Gori's edition of Condivi, 1746, p. 76; Lawrence Gallery 59 (pl. 24); E. Galichon, *Gazette des Beaux-Arts*, 2nd series, ix (1874), pp. 201ff.; JCR 79; F. Wickhoff, *Mitteilungen des Instituts für Osterreichische Geschichtsforschung*, iii (1882), pp. 433f.; BB 1535; Frey 57; Thode 363; E. Panofsky, *Jahrbuch für Kunstgeschichte*, i (1921-2), Buchbesprechungen, cols. 50f.; the same, *Handzeichnungen des Michelangelo*, Leipzig, 1922, no. 9; Popp, *Medici-Kapelle*, pp. 147f.; Brinckmann 55; E. Panofsky, *Studies in Iconology*, New York, 1939, pp. 218ff.; Tolnay 1948, pp. 112f., 148, 199, 221 (no. 117); G. Kleiner, *Begegnungen Michelangelos mit der Antike*, Berlin, 1950, pp. 40f.; Wilde 55; Dussler 177; Hartt 355; BM exh. 1975, no. 125; Tolnay [ii] 340.

INSCRIBED below in black chalk in Michelangelo's hand: [Mess]^er toma[s]o se questo scizzo no[n] ui piace ditelo a urbino / [acci]o ch[e] io abbi tempo d auerne facto un altro doma[n]dassera / [co]me ui promessi e se ui piace e vogliate ch[e] io lo finisca / [rim]andate me lo. ("Master Tommaso, if you don't like this sketch tell Urbino [Michelangelo's servant] in time for me to make another by tomorrow evening, as I promised; and if you do like it and want me to finish it, send it back to me.")

The "Master Tommaso" for whose approval Michelangelo submitted this drawing was Tommaso de' Cavalieri, a young nobleman whom he had met in Rome towards the end of 1532 and to whom he became passionately attached. His letters refer to a number of drawings made for Cavalieri in the course of 1533 (for Michelangelo's "presentation drawings" see under no. 15). The final drawing of *The Fall of Phaethon*, now at Windsor (Popham-Wilde 430; Hartt 358), differs in every detail from the trial *modello* in the British Museum, and is somewhat larger and even more highly finished. It was begun in Rome and sent from Florence at the end of August 1533. Another trial *modello* is in the Venice Accademia (177; Hartt 357).

The subject of the fall of Phaethon follows the account in Ovid (*Metamorphoses*, i, 750ff.). Phaethon tried to drive the chariot of the Sun but was unable to control the horses and nearly set the Earth on fire. He was killed by a thunderbolt from Jupiter, and fell into the River Eridanus (the Po), typified in the drawing by the River-God

and the swan. His sisters, who had harnessed the horses, were punished by being transformed into poplar trees. Phaethon symbolizes presumptuous ambition and the drawing has been interpreted as an expression of Michelangelo's feelings of temerity in venturing to love Cavalieri.

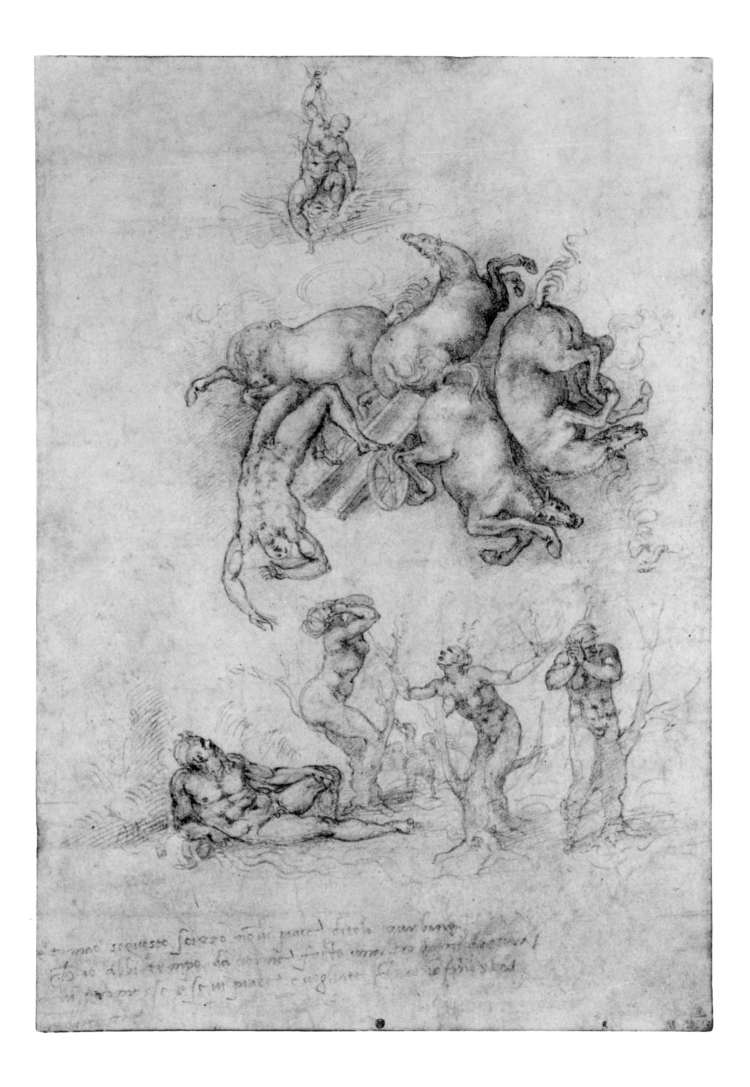

Black chalk. Some unsightly abrasions, visible in the reproduction in Wilde's catalogue, particularly on the right side of the face and the nose, have been restored.

411: 292 mm. Cut into on all four sides, most of all at the bottom. The sheet was originally folded across the middle; the fold can be seen 192 mm. above the bottom edge.

1895-9-15-519

PROVENANCE: Rev. Dr. H. Wellesley (according to JCR); J. Malcolm of Poltalloch; purchased with the Malcolm Collection in 1895.

LITERATURE: JCR 82; Catalogue of the Italian Exhibition in Paris, 1935, under no. 544; O. Giglioli, *Rivista d'Arte*, xx (1938), pp. 174ff.; R [i.e., Carlo Ragghianti], *Critica d'arte*, 23 (1940), Notizie e Letture, pp. vf.; Wilde 59; Dussler 577; BM exh. 1975, no. 119; Tolnay [ii] 329.

MICHELANGELO'S idealistic view of the human form made him reluctant to attempt portraiture: as Vasari (vii, p. 271) tells us, "he abhorred making a likeness from the life, unless the subject was one of perfect beauty." The unique exception that Vasari cites is the lost life-size portrait drawing of Tommaso de' Cavalieri, the young Roman nobleman to whom Michelangelo was passionately devoted and for whom he made some of his finest "presentation drawings" (see no. 14). A note in the margin of a copy of Vasari inscribed by an unidentified annotator who saw the portrait when it was in the possession of Cardinal Farnese (d. 1589), states that it was in black chalk (see *Repertorium für Kunstwissenschaft*, xxix [1906], p. 506).

The Cavalieri portrait is lost, but its general appearance and style can be inferred from the portrait here exhibited, which represents another young man whom Michelangelo admired and presumably also considered "d'infinita bellezza."

The British Museum version was formerly kept under the name of Bronzino, but in the catalogue of the Malcolm Collection it had been given to Michelangelo with a reference to a version in red chalk in the Uffizi (824E) to which is attached a label with the following inscription: *Questo disegno è copiato dall' originale quale è in casa del sig. Gio: Quaratesi et è di mano di Michelagnolo et è il ritratto d' Andrea di Rinieri Quaratesi mio nonno e questo è di mano di Carlin Dolci fatto d' Ottre 1645.* ("This drawing was copied by Carlo Dolci in October 1645 from the original by Michelangelo which is in the house of Signor Giovanni Quaratesi; it is a portrait of my grandfather, Andrea di Rinieri Quaratesi".)

This very specific inscription leaves no doubt that the portrait is of Andrea Quaratesi (1512–85), a member of a distinguished Florentine family and one of Michelangelo's

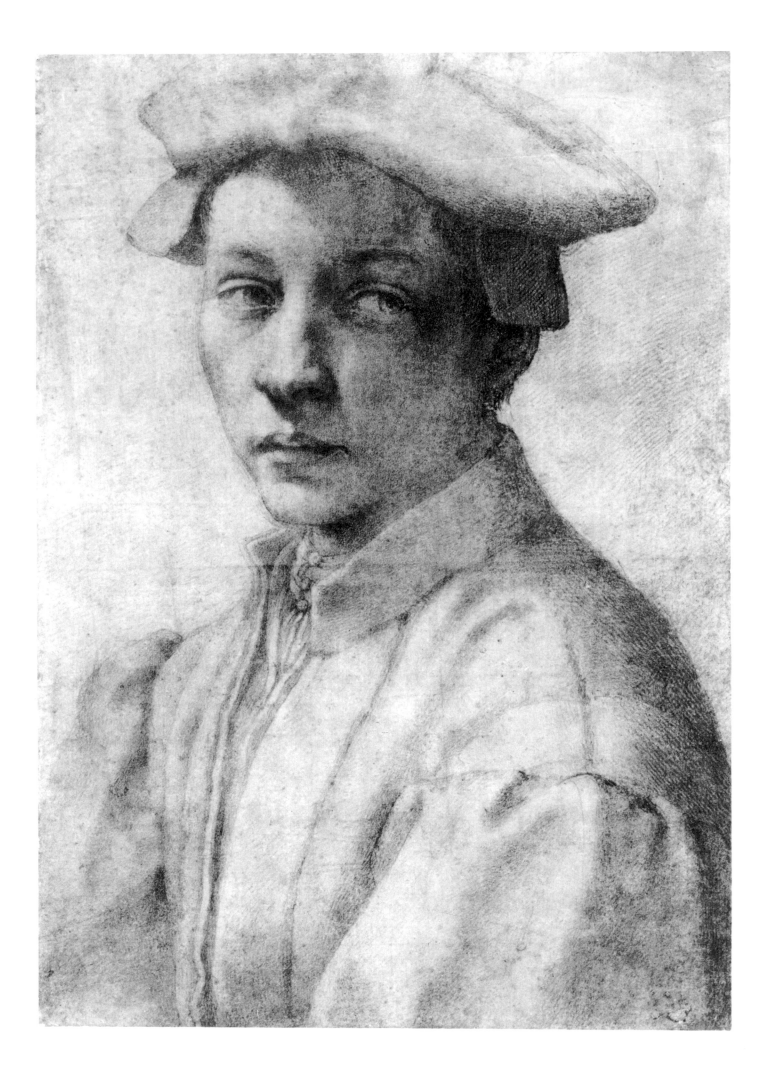

particular friends. Letters from him to Michelangelo survive, dated between the winter of 1530 and the summer of 1532, and an inscription, *Andrea abbi patientia*, on a sheet in the Ashmolean Museum datable in the mid-1520s (Parker 323) suggests that Michelangelo may have been trying to teach him to draw.

Wilde was the first to observe that of the four known versions of this portrait (the other two are in the Louvre and the Boymans–van Beuningen Museum in Rotterdam; all four are reproduced in *Rivista d'arte*, xx [1938], pp. 174ff.), the one in the British Museum "is the earliest [and] the only one in which there is complete harmony between form and graphic style. This, the various *pentimenti*, the technical perfection, and the expressiveness of the face—all suggest that this is the original." Wilde's entirely convincing conclusion is followed only by Tolnay; the drawing was rejected by Dussler and Hartt.

RECTO: black chalk. VERSO: black chalk, with the exception of one small figure traced from the recto which is in red chalk.

385: 253 mm. WM: JCR *Oxford*, no. 40. Slightly trimmed on the left.

1895–9–15–518

PROVENANCE: F. Cicciaporci and B. Cavaceppi (according to Ottley); W. Y. Ottley (sale, London, T. Philipe, 1814, 23 June, lot 1768); Sir T. Lawrence (L. 2445); S. Woodburn (sale, Christie's, 1860, 4 June, lot 125, bt, *Clément*, £27–6–0); E. Galichon (L. 856; sale, Paris, Clément, 1875, 10 May, lot 16); J. Malcolm of Poltalloch (bought for £220 at the Galichon sale); purchased with the Malcolm Collection in 1895.

LITERATURE: Ottley 33 (recto); Lawrence Gallery 84; JCR 80; BB 1536; Steinmann 75A, B; Frey 79, 80; Thode 364; Brinckmann 64; A. E. Popp, *Belvedere*, viii (1925), Forum, p. 75; Tolnay 1930, p. 522; the same, *Art Quarterly*, iii (1940), p. 145, note 6; the same, 1951, p. 75; Wilde 60; Dussler 333; Tolnay 1960, p. 186 (no. 178); Hartt 374, 375; BM exh. 1975, no. 131; Tolnay [iii] 350.

THE early 1530s marked a crisis in Michelangelo's life and in his art. The failure of Clement VII's diplomatic policy resulted in 1527 in the disastrous Sack of Rome, which in its turn brought about the expulsion from Florence of the ruling Medici dynasty and the setting up of a republican government of which Michelangelo was a supporter. In 1529 Clement was reconciled with the Emperor Charles V, who agreed to restore the Medici and laid siege to Florence.

Michelangelo was given charge of the fortifications by the Republican government and did much to improve them, but when Florence eventually capitulated in August 1530 he was given immunity by the Pope on condition that he continued work on the Medici Chapel. From 1532 he began spending long periods in Rome and in September 1534 moved there for good. He never returned to Florence and the chapel was left unfinished. The first work that he undertook in Rome was the *Last Judgment* on the altar-wall of the Sistine Chapel. This was originally commissioned by Clement, probably in 1533, and after his death in September 1534 the project was enthusiastically taken up by his successor, Paul III. Michelangelo had completed the *modello* before he returned to Florence for the last time, in the summer of 1534. He began work on the fresco itself in the late autumn of 1536, and it was unveiled on 31 October 1541.

The altar-wall had previously been decorated with a number of separate frescoes at different levels, including an *Assumption of the Virgin* by Perugino above the altar and, at the very top, two lunettes by Michelangelo himself which were part of his earlier ceiling decoration. The *Last Judgment* as finally carried out occupies the entire area of the wall including the lunettes, but, as Wilde was the first to observe (*Die Graphischen*

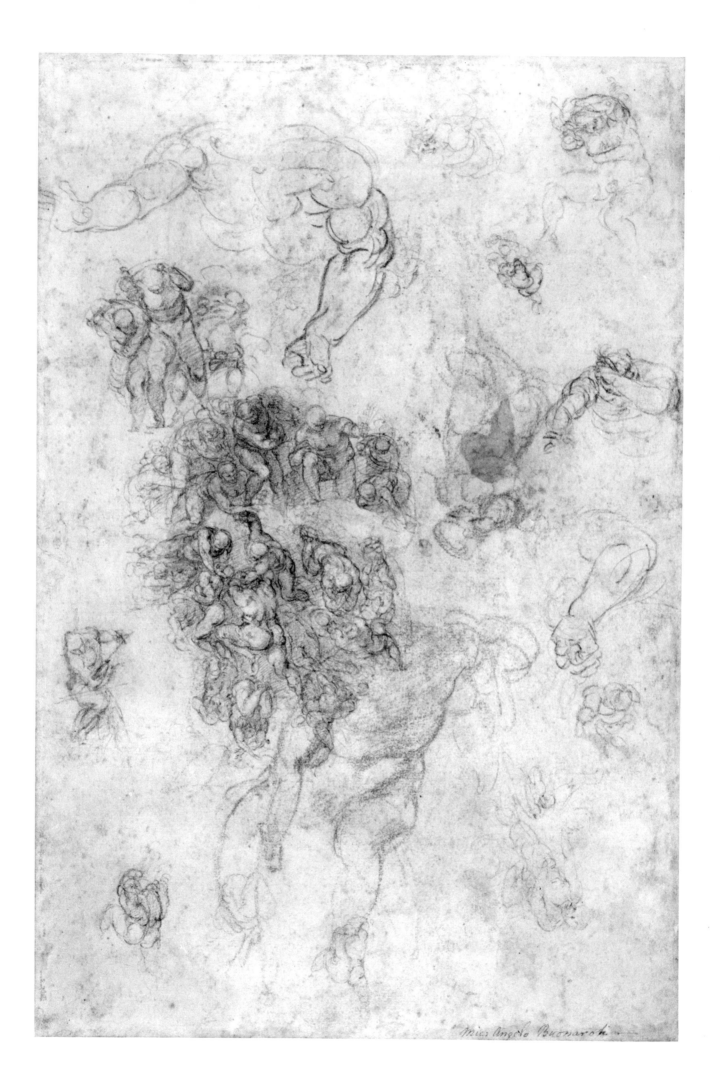

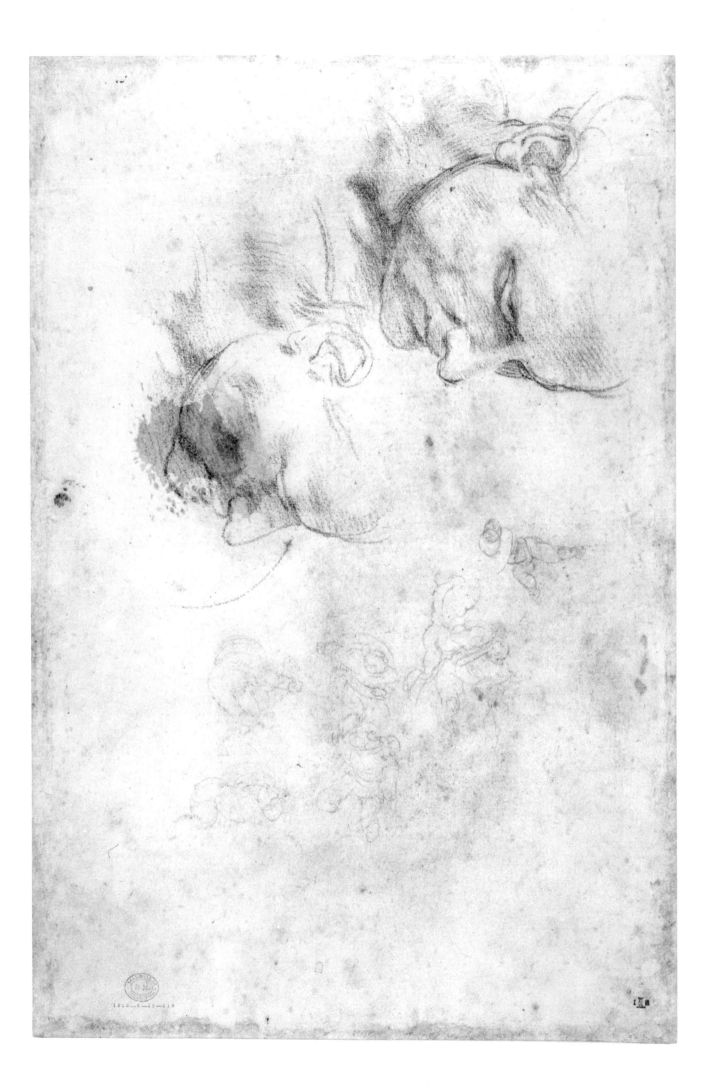

Künste, N.S., i [1936], pp. 7ff.), an early project in the Casa Buonarroti shows the whole composition not only occupying a smaller area but also incorporating Perugino's altarpiece. Like the Sistine Ceiling, which can be seen as the pictorial equivalent of the first project for the tomb of Julius II, the *Last Judgment* is likewise conceived in sculptural terms, as a vast high relief; but the contrast between the two shows that Michelangelo had in the interval undergone a profound spiritual crisis. The disaster of 1527 and the changed attitude of mind that was to lead to the Counter-Reformation had combined by the 1530s to make a radical change in the intellectual climate of Rome. In the *Last Judgment* the pictorial subtlety and grace of the ceiling decoration and the humanist Neoplatonic emphasis on the ordered structure of the universe have been, as it were, burnt away, and the human figure is now used as a vehicle for a direct and highly personal expression of mystical emotion—so personal indeed, that the later Counter-Reformation Popes failed to understand the intensely spiritual quality of the *Last Judgment*. Paul IV, for example, found the nudities so objectionable that he considered having them painted over, and this was finally done, on the recommendation of the Council of Trent, shortly after Michelangelo's death. The contrast between the two paintings is apparent in the drawings for them: the fine black chalk technique that Michelangelo developed for the studies for the *Last Judgment* seems to have an almost deliberate lack of charm, when compared with some of the ceiling studies.

The British Museum sheet of sketches must belong to a fairly late stage in the working-out of the composition. The principal study, on the left of the sheet, corresponds in essentials, though not in detail, with the group of Martyrs, with the Seven Deadly Sins and the Damned below, which occupies the center of the right-hand side of the fresco. Two of the Martyrs are identifiable in the drawing by their attributes: the figure kneeling on one knee to the right of the group who grasps a sheaf of arrows in his extended left hand must be St. Sebastian, while the crouching figure on the extreme right is St. Catherine with part of the wheel in her left hand. The three figures above and to the left of the Martyrs are presumably connected with the group in the same position in the fresco, immediately to the right of Christ, but they do not correspond with any of the figures as painted.

Most of the other small sketches on the recto and the verso are separate studies for figures in the *Last Judgment*. Some of those in the verso were traced through from the group of the Damned on the other side. The purpose of the two large-scale drawings of a man's head on the verso is unknown.

19 LAMENTATION OVER THE DEAD CHRIST recto.
A NUDE MAN STANDING verso.

RECTO: black chalk, partly stippled. Considerably rubbed in places. VERSO: red chalk; some corrections to the drawing of the right hip in black chalk.

282: 262 mm. Trimmed on all four sides.

1896–7–10–1

PROVENANCE: Undecipherable collector's mark (not in Lugt); C. M. Metz (according to inscription on his facsimile engraving); Earl of Warwick (L. 2600; sale, Christie's, 1896, 20 May, lot 232).

LITERATURE: Engraved in facsimile (in reverse) by C. M. Metz (Weigel 4574, where the original is incorrectly stated to be in the Louvre); BB 2486; S. Colvin, *Drawings of the Old Masters in the University Galleries and in the Library of Christ Church, Oxford*, Oxford, 1907, under no. 37; P. d'Achiardi, *Sebastiano del Piombo*, Rome, 1908, pp. 312f., 318f.; Thode 339; E. Panofsky in *Festschrift für J. Schlosser*, Vienna, 1927, p. 161, note; L. Dussler, *Sebastiano del Piombo*, Basle, 1942, p. 191 (no. 217); R. Pallucchini, *Sebastian Viniziano*, Milan, 1944, pp. 82, 177; Wilde 64; Dussler 578; BM exh. 1975, no. 141; Tolnay [ii] 270.

THIS drawing, once in the collection of the Earls of Warwick and known as the "Warwick *Pietà*," is more accurately described as a *Lamentation over the Dead Christ*. It is one of those that recent critics have given to Sebastiano del Piombo (see under no. 8), but Wilde and Tolnay are surely right in reasserting the traditional attribution to Michelangelo.

The right-hand part of a very slight sketch for a similar composition is at Windsor (12769; Popham-Wilde no. 433). The two have in common the figure kneeling to the right of the Virgin and in the British Museum drawing partly supporting her; in the Windsor sketch, where this figure alone is elaborated, he is holding the head of Christ.

The purpose of the drawing is unknown, but there is general agreement that it can be dated in the mid-1530s, in the period of the *Last Judgment*. Wilde conjectures that it is for a painting; to Tolnay the compactness of the composition suggests that it could be a project for a marble *tondo*.

The Herculean nude on the verso is too weak to be by Michelangelo himself, but is probably a product of his studio, derived perhaps from a drawing or three-dimensional model for one of the "Slaves" intended for the tomb of Julius II. Wilde suggests that the black chalk strokes round the waist and right buttock may be corrections by Michelangelo himself.

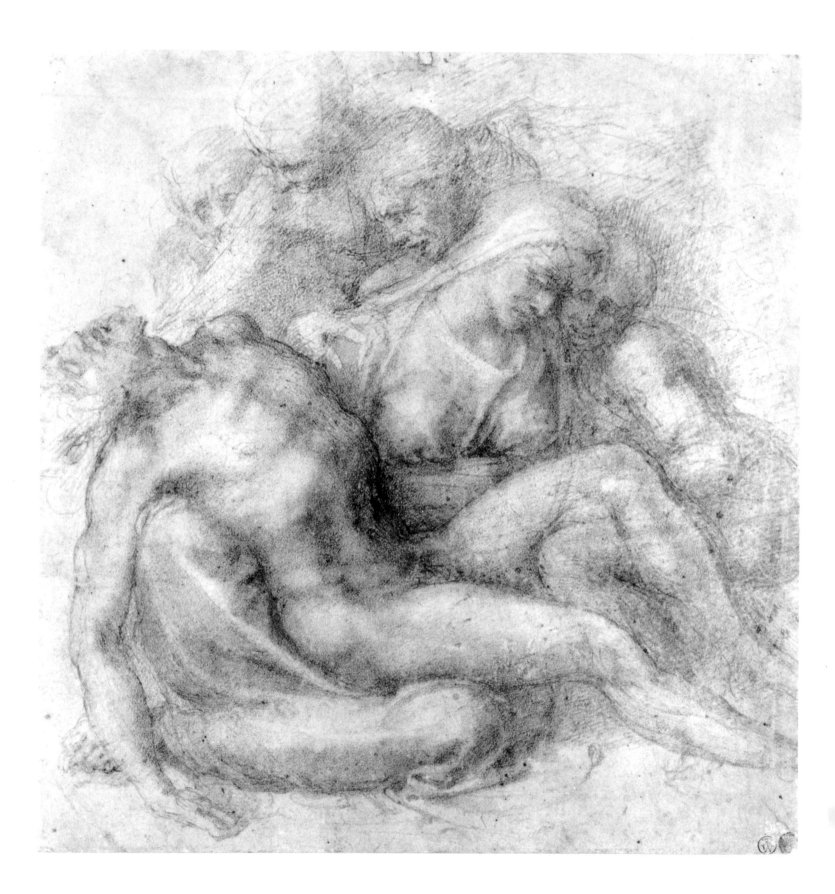

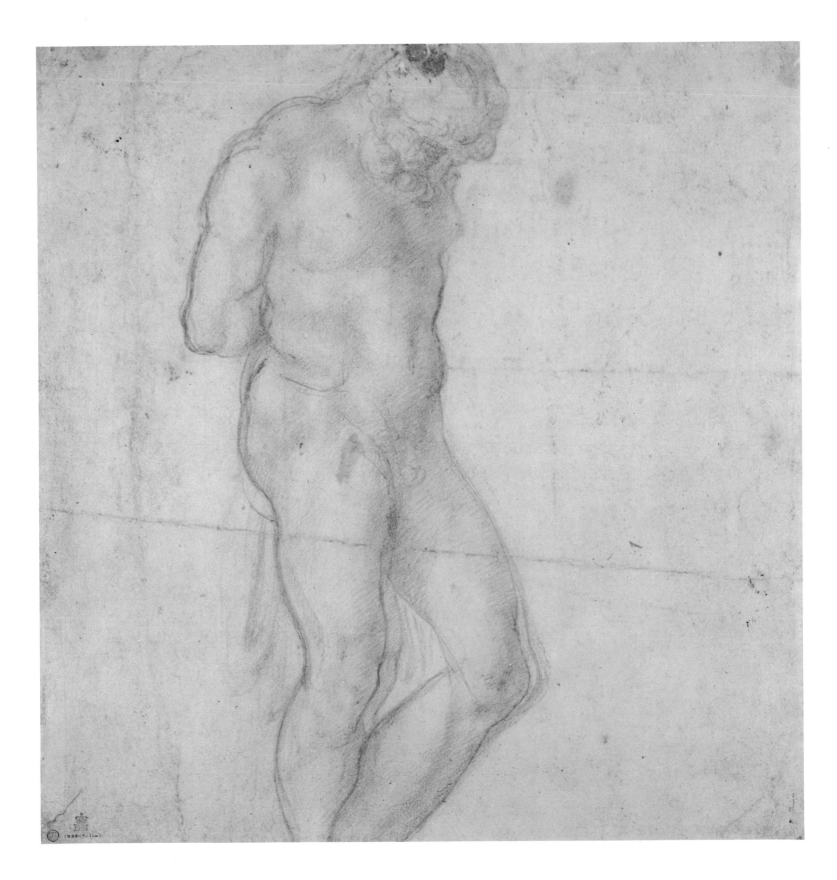

20 DESIGN FOR A SALT-CELLAR

Inscribed at the bottom left in pen and ink, in a sixteenth-century hand: *Michele / angelo / bona a / rotti.*

Black chalk. The vertical axis and some of the horizontals were drawn with a ruler. Many *pentimenti.*

217×155 mm.

1947–4–12–161

PROVENANCE: Earl of Dalhousie? (L. 717a; the evidence for the identification is unsatisfactory, and the coronet seems to be of a Continental type); H. Oppenheimer (sale, Christie's, 1936, 10 July, lot 125); N. R. Colville; Messrs. P. & D. Colnaghi.

LITERATURE: A. E. Popp, *Zeitschrift für bildende Kunst*, lxi (1927–8), pp. 15f.; K. T. Parker, in Oppenheimer sale catalogue; Wilde 66; Tolnay 1954, p. 150, no. 52A; Dussler 582; Hartt 532; BM exh. 1975, no. 139; J. F. Hayward, *Virtuoso Goldsmiths, 1540–1620*, London, 1976, p. 343; Tolnay [iii] 437.

ROBINSON was the first to point out, in a letter to the London *Times* of 29 September 1884, apropos of an old pen-and-ink facsimile then in his own possession and now in the Victoria and Albert Museum (P.&D:E.1322–1927; reproduced in *Burlington Magazine*, xxi [1912], p. 356), that the design corresponds closely with the description of a silver-gilt salt-cellar commissioned from Michelangelo by Francesco Maria I della Rovere, Duke of Urbino, for which a model was made in 1537. Michelangelo's uncharacteristic readiness to accept, and even carry out, a trifling commission of this nature can be explained by his need to conciliate the Duke, who as nephew and heir of Pope Julius II was continually pressing him to complete his uncle's tomb. The description occurs in a letter, dated 4 July 1537, from the Duke's agent in Rome: *gli dico che più mesi essere finito il modello della saliera de rilievo, e principato de argento alcune grampe de animali, dove se ha a posare il vaso della saliera, et a torno di esso vaso ci va certi festoni con alcune mascare et i'nel coperchio una figura de rilievo tutta, con alcuni altri fogliami, secondo Michelangelo ordino et secondo appare nel modello finito detto de sopra.* ("I have to inform you that the relief [i.e., three-dimensional] model for the salt-cellar was completed some months ago, and that work has started on the silver animals' paws on which the bowl will rest; round the bowl will be festoons and masks and on the lid a figure in the round, with foliage, all according to Michelangelo's design and the finished model referred to above.") The drawing differs from his description in that the lid is decorated not with foliage but with ribs terminating in birds' heads.

Unfortunately, the Duke's agent does not specify the number of legs; but though the perspective of the drawing shows only two, diametrically opposite one another,

we agree with Hayward that the design is probably for a circular vessel on a tripod support. The Duke died in October 1538, rather more than a year after the *modello* was shown to his agent, and nothing more is heard of the salt-cellar.

Some critics (Popp, Parker, and Dussler) have dismissed this drawing as a product of the studio, but if it makes a somewhat unfavorable impression at first sight this is because it is an explicit working-drawing executed in part with a ruler. Where the draughtsman has allowed himself to be spontaneous—as in the figure of Cupid on the lid—the handling seems fully compatible with Michelangelo himself.

21 CHRIST ON THE CROSS

Black chalk, to a great extent stippled. Rubbed in places, particularly at the bottom.

370: 270 mm. WM: JCR *Oxford*, no. 33. Trimmed at the top. Two holes mended near the left edge.

1895-9-15-504

PROVENANCE: Vittoria Colonna (see critical note); King of Naples "at Capo di Monte" (according to Ottley sale catalogue); M. Brunet (according to Lawrence Gallery catalogue); W. Y. Ottley (sale, London, T. Philipe, 1814, 21 June, lot 1591); Sir T. Lawrence (L. 2445); King William II of Holland (sale, The Hague, 1850, 12 August etc., probably lot 105, bt, *Woodburn, 240 fls*); S. Woodburn (sale, London, Christie's, 1860, 4 June, lot 113, bt, *Ensor, £42*, according to the Malcolm catalogue "for Mr Brooks of Liverpool"); J. Malcolm (probably the "Crucifixion in Italian chalk" recorded in the MS "Memorandum of the prices paid at different times for drawings in my collection" as having been bought for £80 on 31 January 1873 from Sir J. C. Robinson); purchased with the Malcolm Collection in 1895.

LITERATURE: Lawrence Gallery 22; JCR 67; Loeser 1897, p. 354; BB under 1724A; Steinmann, ii, p. 502, note 1; Frey 287; Thode 353; Tolnay, *Repertorium*, xlviii (1928), pp. 198f.; the same 1951, p. 144; Wilde 67; Dussler 329; Tolnay 1960, p. 195, no. 198; Hartt 408; BM exh. 1975, no. 129; Tolnay [iii] 411.

APART from the two angels this drawing corresponds with the description given by Condivi (p. 202), Michelangelo's friend and biographer, of a "presentation drawing" (see no. 15) made for Vittoria Colonna: "un disegno di Giesu Christo in croce, non in sembienza di morto come comunemente s'usa, ma in atto di vivere, col volto levato al padre e par si dica: 'Heli heli'; dove si vede quel corpo non come morto abandonato cascare, ma come vivo per l'acerbo supplitio risentirsi e scontorcersi" ("A drawing of Jesus Christ on the Cross, not dead as he is usually shown, but alive with His face turned to His Father, so that he seems to be uttering the words 'Eli, Eli'; the body is not shown sagging as it would if it were dead, but alive and struggling in agony").

The generally accepted identification of the present drawing with the actual one described may well be correct. It is true that Condivi does not mention the half-figures of angels, but it is probably to her drawing of Christ on the Cross that Vittoria Colonna is referring in a letter to Michelangelo in which she expresses pleasure in finding "the angel on the right hand the more beautiful, since on the Last Day you [Michelangelo] will be placed on the right hand of the Lord."

Vittoria Colonna, Marchesa di Pescara (1492–1547), is probably best remembered today for her intense spiritual friendship with Michelangelo. She had made his acquaintance not later than 1531, and the correspondence relating to her drawing of Christ on the Cross, though undated, is generally placed towards the end of the 1530s. In a

letter thanking Michelangelo for it she says that she has studied the drawing through a magnifying glass, and has never seen anything so beautifully finished. It is one of the last completely finished presentation drawings made in the manner of the Cavalieri sheets (see no. 16).

It has been suggested that the composition is incomplete, and was originally to have included standing figures of the Virgin and St. John. We agree with Hartt that the arguments for this are unconvincing. Berenson and Frey dismissed the present drawing as a copy, and it is doubted by Dussler. It was accepted by Thode, followed by Wilde and Hartt. Tolnay implies that only the body of Christ is by Michelangelo himself, and that the rest of the drawing may be by another weaker hand. This distinction seems to us oversubtle: we feel no doubt that the drawing is wholly by Michelangelo.

22 THE VIRGIN ANNUNCIATE recto.

THE VIRGIN ANNUNCIATE verso.

Inscribed in ink on recto, top right: *63*; on verso, top right: *michel Angelo buona Roti*, and lower left: *n.64*.

Black chalk.

348: 224 mm. Cut on the right. Fragment of a WM: small star, like JCR *Oxford*, no. 16.

1900–6–11–1

PROVENANCE: Casa Buonarroti and J. B. J. Wicar (according to Lawrence Gallery catalogue); Sir T. Lawrence (L. 2445); S. Woodburn (sale, Christie's, 1860, 4 June, lot 101, bt, *Tiffin*, £6–10–0); Miss K. Radford, by whom presented.

LITERATURE: Lawrence Gallery 60; BB 1519; Vasari Society, ii (1906–7), p. 5; P. d'Achiardi, *Sebastiano del Piombo*, Rome, 1908, p. 319; Frey 190; Thode 340; E. Panofsky, *Handzeichnungen Michelangelos*, Leipzig, 1922, no. 19; Brinckmann 78; Tolnay 1930, p. 524; F. Baumgart, *Bollettino d'arte*, xxvii (1934–5), p. 346; the same, *Festschrift für A. Goldschmidt*, Berlin, 1935, p. 136; L. Dussler, *Sebastiano del Piombo*, Basle, 1942, p. 191 (no. 216); Wilde 71; Wilde 1959, pp. 374ff.; Dussler 179, 579; Tolnay 1960, p. 206, no. 220; A. Perrig, *Wallraf-Richartz-Jahrbuch*, xxiv (1962), pp. 279ff.; Hartt 431; BM exh. 1975, no. 145; Tolnay [iii] 394.

PART of the rest of the composition, with the Angel, is on the verso of another drawing of the *Annunciation*, also in the British Museum (Wilde 72). The right hand and part of the forearm of the Angel can be seen on the right of the present drawing, and when the two sheets are placed in the correct relation as thus indicated the exact correspondence of the chain-lines in the paper establishes that they were originally part of one and the same sheet. They do not now fit together exactly, for the trimming of the upper edge of Wilde 72 recto has cut away the middle part of the Angel's arm, as the trimming of the right-hand edge has cut away his legs.

The drawings on the undivided sheet are studies for two paintings which according to Vasari (viii, p. 272) were executed by Marcello Venusti on the basis of drawings supplied by Michelangelo. One, painted for the Cesi Chapel in S. Maria della Pace, has disappeared, but its composition is preserved in a small-scale copy now in the Galleria Nazionale in Rome (Wilde 1959, fig. 12); the other is still in S. Giovanni in Laterano (ibid., fig. 8). External evidence suggests that the Cesi altarpiece dates from the end of the 1540s; the other was presumably executed at about the same time. Carefully finished drawings ("cartonetti") in black chalk of the two compositions are respectively in The Pierpont Morgan Library (iv, 7; BB 1656; Wilde 1959, fig. 1) and the Uffizi (229F; BB 1644; Wilde 1959, fig. 7). Most critics have followed Berenson

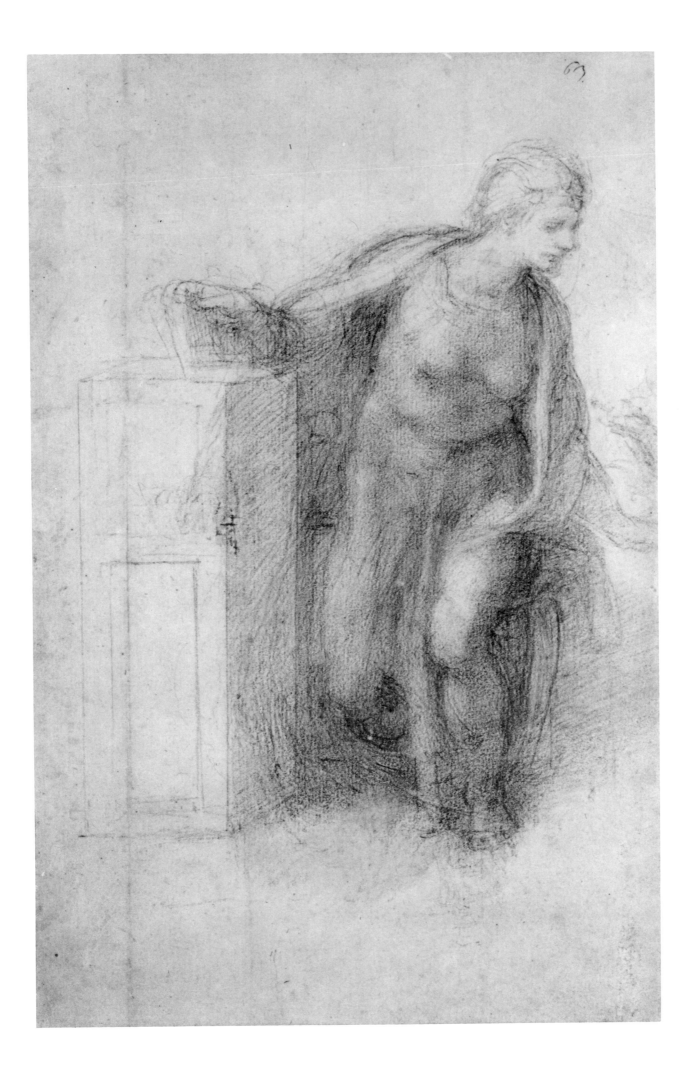

in attributing them to Venusti. Wilde was the first to recognize in them the hand of Michelangelo himself.

Apart from the placing of the Angel, Wilde 72 recto comes very close to the Cesi composition, with which it corresponds exactly in the *pentimenti* for the head (the existence of which was first pointed out by Wilde in his 1959 article) and left arm; Wilde 71 recto/72 verso corresponds with the Lateran *Annunciation* in the relation of the figures and their stance, the principal difference being in the angle of the Virgin's torso and the position of her arms. It should be noted that the alternative placing of the Angel on Wilde 72 verso shows him hovering in the air as in the Cesi composition. These drawings are accepted by all modern critics except Perrig, whose argument in favor of Venusti's authorship seems to us without substance: furthermore, they in no way resemble those attributed to him by Bernice Davidson on the basis of their connection with his independent works (*Master Drawings*, xi [1973], pp. 3 ff.).

Traced through on the verso is the left leg of the recto figure; also, likewise in black chalk and drawn with the sheet the other way up, a very summary sketch of an Annunciate Virgin seated with her right elbow resting on the faldstool and her head turned to look upwards over her left shoulder. Her pose is essentially that of the Virgin in the *Annunciation* on Wilde 72 recto and the position of her head corresponds with the *pentimento* in the same figure. The verso sketch has, inexplicably, been either ignored altogether in the literature or dismissed as the work of a later, feeble hand, but its presence on the same sheet as other studies of the subject undoubtedly by Michelangelo provides a strong prima facie argument in its favor; and indeed the graphic shorthand seems to us entirely characteristic of Michelangelo himself, as does the masterly economy with which the weight and movement of the figure are suggested in a few rapid strokes. This sketch in fact represents an intermediate stage in the design between Wilde 72 recto and the final solution, which it more closely resembles in the position of the head and right arm, though the right shoulder is still raised as in Wilde 72 recto.

Wilde's contention that the Lateran composition must have been the earlier of the two is supported by the placing of the sketch on Wilde 71 verso, which on the undivided sheet was at right angles to the *Annunciation* on Wilde 72 recto. This suggests that Michelangelo had folded the paper, and consequently that Wilde 71 recto/72 verso was drawn first.

We can offer no explanation of the emphatic semicircular outline to the right of the Virgin's figure.

23 CHRIST DRIVING THE MONEY-CHANGERS FROM THE TEMPLE recto. FOUR SKETCHES FOR THE SAME COMPOSITION verso.

Black chalk.

178: 372 mm. Trimmed at the top (see the verso). Made up of five vertical strips and a transverse one (at the bottom), stuck together. The bottom right corner made up.

1860–6–16–2(3)

PROVENANCE: Casa Buonarroti; J. B. J. Wicar; Sir T. Lawrence; William II of Holland (sale, The Hague, 1850, 12 August, lot 129, as "M. Venusti," bt, *Woodburn, 530 fls*); S. Woodburn (sale, Christie's, 1860, 4 June, lot 109, bt, *Tiffin, £13–10–0*).

LITERATURE: Lawrence Gallery 88 (pl. 7); BB 1517; Frey 255, 256; Thode 332; Brinckmann 69 (recto); J. Wilde, *Mitteilungen des Kunsthistorichen Instituts in Florenz*, iv (1932), p. 50; Tolnay 1951, p. 93; Wilde 78; Dussler 167; Tolnay 1960, p. 212 (no. 235); Hartt 447; BM exh. 1975, no. 167; Tolnay [iii] 387.

THE style suggests a very late date, perhaps as late as the second half of the 1550s. The subject had a particular significance at that period, as symbolizing the movement promoted by successive Popes—especially Paul IV (1555–9)—towards the reform of the Church from within. Two other studies for the same composition are also in the British Museum (Wilde 76 and 78) and a fragment of a fourth is in the Ashmolean Museum, Oxford (Parker 328; Hartt 473).

Their purpose is unknown. The study here exhibited was probably Michelangelo's final solution, since it corresponds exactly with the figures—shown clothed—in a painting by Marcello Venusti in the National Gallery in London. Though Venusti knew Michelangelo and often used drawings by him as the basis for small-scale devotional pictures, the National Gallery painting may not necessarily have been intended as the end-product of this sequence of studies: in its block-like cohesion the group of figures is not satisfactorily integrated with Venusti's spacious architectural setting, in which it also seems incongruously out of scale. Tolnay observed that the curved outline of the group would fit into a shallow lunette, and suggested that such a lunette might at some stage have been intended for the Cappella Paolina in the Vatican, where Michelangelo was working between 1542 and 1550. But the suggestion of an architectural background composed of two arched openings in the sketch for the same composition on Wilde 76 verso is an argument against the hypothesis that Michelangelo had a lunette in mind.

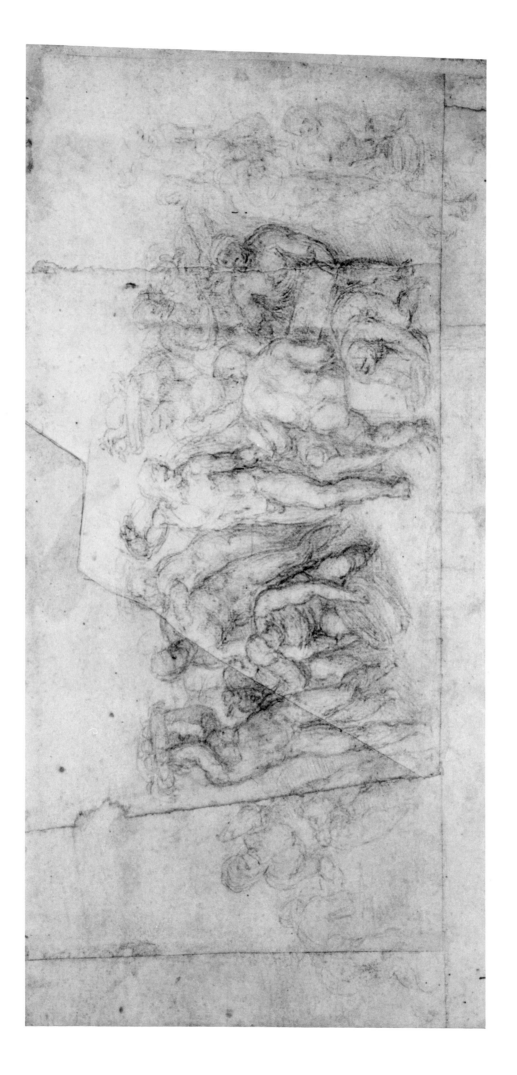

24 CHRIST ON THE CROSS BETWEEN THE VIRGIN AND ST. JOHN

Black chalk. White, used to cover altered lines. The Cross was drawn with a ruler.

412: 279 mm.

1895–9–15–510

PROVENANCE: Casa Buonarroti and J. B. J. Wicar (according to Lawrence Gallery); Sir T. Lawrence (L. 2445); S. Woodburn (sale, Christie's, 1860, 4 June, lot 116, bt, *Colnaghi* £16–5–6; J. Malcolm of Poltalloch; purchased with the Malcolm Collection in 1895.

LITERATURE: Lawrence Gallery 25; JCR 73; BB 1530; Frey 128; Thode 357; E. Panofsky, *Handzeichnungen Michelangelos*, Leipzig, 1922, no. 17; Brinckmann 75; Tolnay 1927, pp. 201f.; R. Wittkower, *Burlington*, lxxviii (1941), pp. 159f.; Tolnay 1951, p. 154; Wilde 82; Dussler 175; Tolnay 1960, p. 224, no. 256; Hartt 429; BM exh. 1975, no. 183; Tolnay [iii] 419.

TOWARDS the end of his life Michelangelo became increasingly preoccupied with spiritual meditation. In his very late drawings he perfected a uniquely personal, and wholly inimitable style, in which human figures are used as symbols of a mystical vision of extraordinary intensity and pathos. The studies for this composition of the Crucified Christ must date from the 1550s. Others are in the Louvre (700, Hartt 420; 720, Hartt 418, 419; 842, Hartt 410), Windsor (12775, Hartt 423; 12761, Hartt 425), the Ashmolean Museum, Oxford (Parker 343; Hartt 426) and the Seilern Collection, London (Hartt 430). Their purpose is a matter of conjecture. It is true that a painting by Marcello Venusti is based on one of them, with the addition of the two angels from the earlier drawing of the subject probably made for Vittoria Colonna (see no. 21); but Wilde is surely right in objecting that Michelangelo himself would hardly have been responsible for such a combination. Tolnay (1960, p. 223) was the first to observe on the verso of Windsor 12761 a roughly triangular outline drawn round the figure of Christ on the other side; he explained this as a block of stone and concluded that the studies were for a marble group in the round. It is also possible that these drawings were intended as objects in themselves, not necessarily for presentation but as private devotional images.

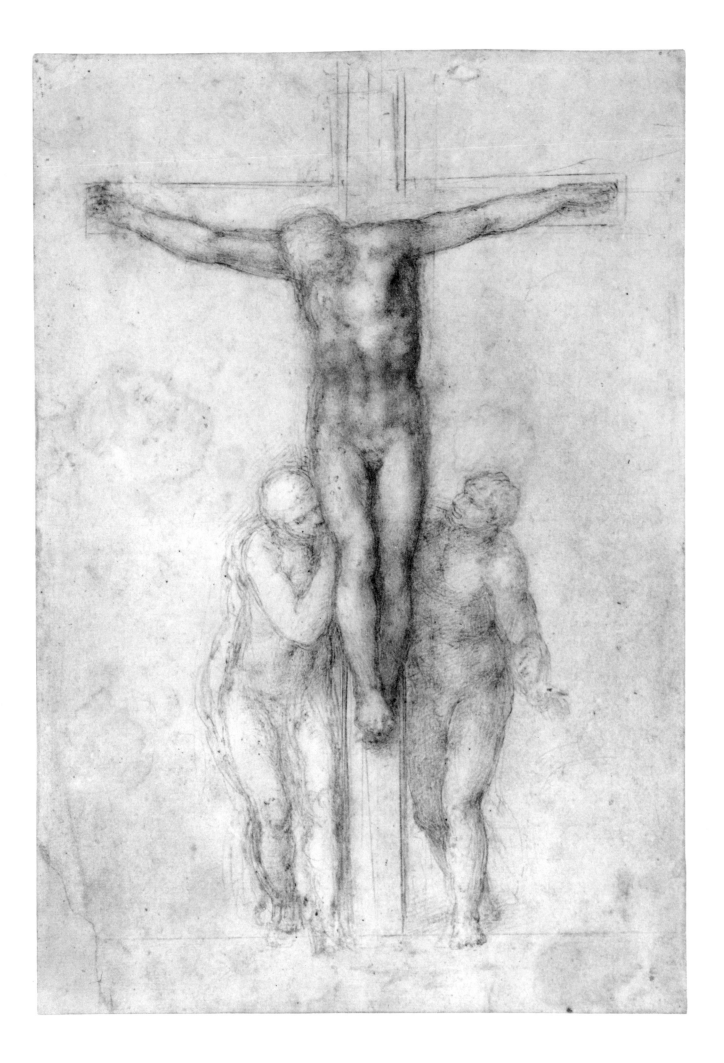

CONCORDANCES

Wilde	Pierpont Morgan exh.	BB	Pierpont Morgan exh.
1	1	1476	3
5	2	1479	2
6	3	1482	14
7	4	1483	4
8	5	1484	5
10	6	1485	6
11	7	1490	12
16	9	1495	10
15a	8		
26	10	1496	11
28	11	1517	23
33	12	1519	22
39	13	1519A	7
41	14	1522	1
42	15	1527	13
55	16	1530	24
59	17	1535	16
60	18	1536	18
64	19	1689	15
66	20	2483	9
67	21	2486	19
71	22	2488	8
78	23		
82	24		

WORKS REFERRED TO IN ABBREVIATED FORM

Baumgart 1937

Fritz Baumgart. "Die Jugendzeichnungen Michelangelos bis 1506," Sonderdruck aus dem *Marburger Jahrbuch für Kunstwissenschaft*, x (1937).

BB (*followed by number*)

Bernard Berenson. *The Drawings of the Florentine Painters.* Amplified edition. Vol. ii (catalogue). Chicago, 1938.

BM exh. 1975

Drawings by Michelangelo in the Collection of Her Majesty the Queen at Windsor Castle, the Ashmolean Museum, the British Museum and other English collections: An Exhibition Held in the Department of Prints and Drawings in the British Museum, 6th February to 27th April 1975.

Brinckmann (*followed by number*)

A. E. Brinckmann. *Michelangelo-Zeichnungen.* Munich, 1925.

Burger

Fritz Burger. *Geschichte des florentinischen Grabmals von den ältesten Zeiten bis Michelangelo.* Strasbourg, 1904.

Burlington

The Burlington Magazine. London, from 1902.

Condivi

C. Frey, ed. *Vita di Michelangelo Buonarroti raccolta per Ascanio Condivi da La Ripa Transone* (Rome, 1553). Berlin, 1887.

Dussler (*followed by number*)

Luitpold Dussler. *Die Zeichnungen des Michelangelo: Kritischer Katalog.* Berlin, 1959.

Frey (*followed by number*)

Karl Frey. *Die Handzeichnungen Michelagniolos Buonarroti: Herausgegeben und mit kritischem Apparate versehen.* 3 vols. Berlin, 1909–11.

Geymüller

Heinrich von Geymüller. *Michelangelo Buonarroti als Architekt: Nach neuen Quellen.* Munich, 1904.

Hartt (*followed by number*)

Frederick Hartt. *The Drawings of Michelangelo.* London, 1971.

JCR (*followed by number*)

J. C. Robinson. *Descriptive Catalogue of Drawings by the Old Masters, Forming the Collection of John Malcolm of Poltalloch, Esq.* 2nd ed. London, 1876.

JCR *Oxford*

J. C. Robinson. *A Critical Account of the Drawings by Michel Angelo and Raffaello in the University Galleries, Oxford* Oxford, 1870. (*When followed by a number, the reference is to the list of watermarks on pp. 362ff.*)

L (*followed by number*)

Frits Lugt. *Les marques de collections de dessins et d'estampes......* Amsterdam, 1921.

Lawrence Gallery

The Lawrence Gallery . . . Tenth Exhibition: A Catalogue of One Hundred Original Drawings by Michael Angelo. London, 1836. Plate references are to: *Lawrence Gallery: A Series of Facsimiles of Original Drawings, by M. Angelo Buonarroti, Selected from the Matchless Collection Formed by Sir Thomas Lawrence . . .*, London, published by S. and A. Woodburn, 1853.

Loeser 1897	C. Loeser. "I disegni italiani della raccolta Malcolm," *Archivio storico dell' arte*, iii (1897), p. 353.
Ottley (*followed by number*)	William Young Ottley. *The Italian School of Design; Being a Series of Facsimiles of Original Drawings. . . .* London, 1823.
Parker (*followed by number*)	K. T. Parker. *Catalogue of the Collection of Drawings in the Ashmolean Museum.* Vol. ii: *The Italian Schools.* Oxford, 1956.
Popham-Wilde (*followed by number*)	A. E. Popham and Johannes Wilde. *The Italian Drawings of the XV and XVI Centuries in the Collection of His Majesty the King at Windsor Castle.* London, 1949.
Popp, *Medici-Kapelle*	A. E. Popp. *Die Medici-Kapelle Michelangelos.* Munich, 1922.
Popp 1925/6	A. E. Popp. "Bemerkungen zu einigen Zeichnungen Michelangelos," *Zeitschrift für bildende Kunst*, 59 (1925/6), pp. 134ff.
Steinmann (*followed by number*)	Ernst Steinmann. *Die Sixtinische Kapelle.* Vol. ii: *Michelangelo.* Munich, 1905. (*The numbers refer to the catalogue of drawings on pp. 587ff.*)
Symonds	John Addington Symonds. *The Life of Michelangelo Buonarroti Based on Studies in the Archives of the Buonarroti Family at Florence.* 2 vols. London, 1893.
Thode (*followed by number*)	The numbers refer to the "Verzeichnis der Zeichnungen" contained in vol. iii of: Henry Thode. *Michelangelo: Kritische Untersuchungen über seine Werke.* 3 vols. Berlin, 1908–13.
Tolnay 1927	K. Tolnai. "Die Handzeichnungen Michelangelos im Codex Vaticanus," *Repertorium für Kunstwissenschaft*, xlviii (1927), pp. 157ff.
Tolnay 1928	Karl Tolnai. "Die Handzeichnungen Michelangelos im Archivio Buonarroti," *Münchner Jahrbuch*, N.S., v (1928), pp. 377ff.
Tolnay 1930	K. Tolnai's article on Michelangelo Buonarroti in Thieme-Becker, *Allgemeines Lexikon der bildenden Künstler*, xxiv (1930), pp. 515ff.
Tolnay 1943	Charles de Tolnay. *Michelangelo.* Vol. i: *The Youth of Michelangelo.* Princeton, 1943.
Tolnay 1945	Charles de Tolnay. *Michelangelo.* Vol. ii: *The Sistine Ceiling.* Princeton, 1945.
Tolnay 1948	Charles de Tolnay. *Michelangelo.* Vol. iii: *The Medici Chapel.* Princeton, 1948.
Tolnay 1951	Charles de Tolnay. *Michel-Ange.* Paris, 1951.
Tolnay 1954	Charles de Tolnay. *Michelangelo.* Vol. iv: *The Tomb of Julius II.* Princeton, 1954.
Tolnay 1960	Charles de Tolnay. *Michelangelo.* Vol. v: *The Final Period.* Princeton, 1960.
Tolnay (*followed by number*)	Charles de Tolnay. *Corpus dei Disegni di Michelangelo.* Novara, 1975– (*in progress; vols. i to iii so far published*). Roman numbers in square brackets refer to the volumes of the corpus.

Vasari Giorgio Vasari. *Le vite de' più eccellenti pittori scultori ed architettori . . . con nuove annotazioni e commenti di Gaetano Milanesi.* 9 vols. Florence, 1878–85.

Wilde (*followed by number*) Johannes Wilde. *Italian Drawings in the Department of Prints and Drawings in the British Museum: Michelangelo and His Studio.* London, 1953.

Wilde 1959 Johannes Wilde. "*Cartonetti* by Michelangelo," *Burlington Magazine*, ci (1959), pp. 370ff.